*The College History Series*

# DREW
# UNIVERSITY

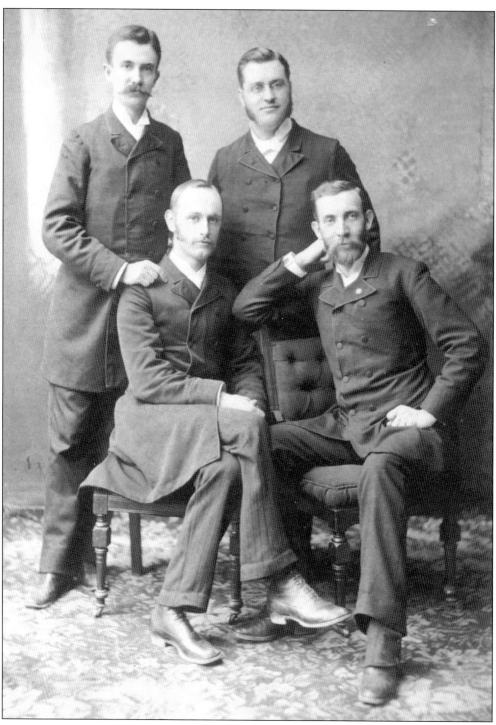

Records provide no clues to the identities of "the Forest Quartette," but the uniformly dressed, serious group posed for this portrait in a local studio sometime between 1888 and 1891. It is likely that the group sang during those years at campus functions and in area churches and religious gatherings.

*The College History Series*

# DREW
# UNIVERSITY

JOHN T. CUNNINGHAM AND REGINA DIVERIO

ARCADIA
PUBLISHING

Published by Arcadia Publishing
Charleston, South Carolina

Printed in the United States of America

Library of Congress Catalog Card Number: 00104048

For all general information contact Arcadia Publishing at:
Telephone 843-853-2070
Fax 843-853-0044
E-mail sales@arcadiapublishing.com
For customer service and orders:
Toll-Free 1-888-313-2665

Visit us on the Internet at www.arcadiapublishing.com

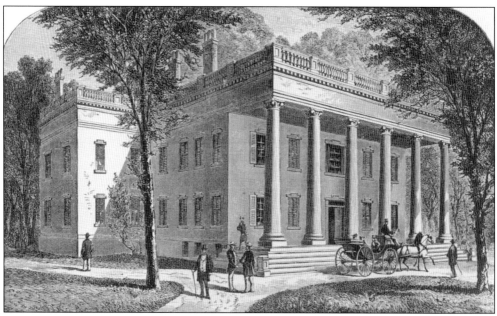

This engraving by an unknown artist of the 1870s provides a splendid image of Mead Hall, the mansion that has served as Drew University's heart since its founding in 1867. The elaborately dressed people and the ornate carriage hint at an opulence that never existed at the school in its early days. After being ravaged by a fire in 1989, the restored building is, more than ever, the university's heart.

# CONTENTS

Acknowledgments                                    6

Introduction                                       7

1.   Gateway to a Campus                           9

2.   Theology under the Oaks                      19

3.   College of Brotherly Love                    45

4.   A Wake-up Call                               61

5.   The Edifice Complex                          71

6.   Transition and Turmoil                       87

7.   Excitement and Audacity                     101

8.   Toward Tomorrow                             115

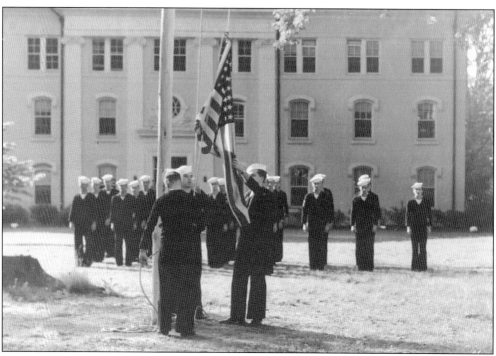

During World War II, when traditional students fell to less than 40 men, the assignment of a V-12 unit to Drew by the U.S. Navy saved the College of Liberal Arts from closure. At about the same time, the first women students were enrolled. At war's end, the sailors were assigned elsewhere and the women became a permanent part of the student body.

# *Acknowledgments*

Histories of Drew University have been written before: the senior editor of this volume is now planning a third edition of his comprehensive University in the Forest, originally published in 1970. Yet the story as recorded by photographers and illustrators for more than 150 years had not been told. To do just that, we searched through hundreds of photographs and illustrations representative of the university's several transformations since its founding in 1867.

We owe an enormous debt to the offices of Development and Alumni Affairs and University Relations for their support. Within those offices we recognize, in particular, Jay Angeletti, who saw the value of this venture, and Jennifer Brauner, Lynne DeLade, and Jim Diverio (Class of 1984). Special thanks also go to George Hayward (Class of 1960) and the late Larry Horner (Class of 1940) for images of a long-ago era of sports. We also thank Kristen Daily (Class of 1998) of the New Jersey Shakespeare Festival. There is never a way to thank sufficiently a library staff, but we nevertheless proffer gratitude to Jean Schoenthaler, Masato Okinaka, and Beth Leiser for guiding us through the university's archives. Finally, the later chapters of the book would not have been possible without the artful skills of the following photographers: Sal Benedetto, Judi Benvenuti, William Clare, Gerry Goodstein, Bob Handelman, G. Steve Jordan, Shelley Kusnetz, Chris Pedota, Jim Sulley, and Steve Wolfe.

John T. Cunningham (Class of 1938) and
Regina Diverio (Graduate School Class of 1996).

# INTRODUCTION

Drew University is set securely beneath towering oak trees on the sharp rise just west of downtown Madison, New Jersey. Founded in 1867 on an unlikely blending of vigorous, old-fashioned Methodism, a shady Wall Street stock manipulator, and a New York City millionaire whose fortune derived from 500 slaves on a Georgia plantation, Drew became the "University in the Forest." Tradition holds that Abby Gibbons, the wife of the New York City slave-holding millionaire William Gibbons, fell in love with "the Forest" in the summer of 1832 as the family rode westward, past the shaded property. Gibbons bought the woodland and, in 1836, completed a spacious Greco-Roman mansion that reminded him of his plantation roots.

The mansion was and is a house to revere. The red brick walls stretch 150 feet wide and 100 feet deep. The entrance hall, 25 feet wide and 50 feet deep, was larger than any house in nearby Madison. The six Ionic columns of the front piazza rose 36 feet to support the porch roof. Gibbons imported exotic woods for interior woodwork. Fire ravaged the then 153-year-old mansion in August 1989. Rebuilt at a cost of $10 million, including air conditioning and controlled heat, this heart of Drew is recognized as the finest Greco-Roman revival structure north of Dixie.

The last Gibbons to live in the mansion died in 1857. The house was shuttered, weeds grew tall in the estate driveways, and the Forest returned to its natural state. The property was available in 1866, when the Methodist Church observed the 100th anniversary of American Methodism and yearned to celebrate it by founding a modern theological seminary. Into the picture stepped the notorious Daniel Drew, whose Wall Street railroad stock dealings were both spectacular and unscrupulous. He gave the church $250,000 to acquire the Gibbons property and another $250,000 to endow a theological seminary on the site. Grateful Methodists named their new institution for Drew, their sole patron. The mansion was christened Mead Hall to honor Drew's wife, Roxanna Mead Drew.

The magnificent building became the school's administrative center, the library, classroom space, and the president's home. The stable that housed Gibbons' thoroughbred race horses was refurbished as a dormitory (Asbury Hall). A former granary was converted into a dining and social area (Embury Hall). Both are still in active use. Daniel Drew soon added four new houses, one for the president, the others for three professors.

Drew Theological Seminary sent ministers to preach throughout the United States. Scores traveled to positions in Far Eastern missions. When WWII erupted, more than 150 Drew Seminary graduates were trapped in missions in Japan, China, and other nations in the Far East. Dr. Henry

Anson Buttz, the fourth president, built the five substantial stone or brick buildings that still form the university's inner circle. Buttz's quintet of structures included Cornell Library, the Hoyt-Bowne dormitory, the seminary building, Bowne Gymnasium, and the Great Hall, formerly the refectory and now home of the Caspersen School of Graduate Studies. Cornell Library was demolished in 1939 to make way for Rose Memorial Library. Part of Bowne Gymnasium has been incorporated into the $7.5 million F.M. Kirby Shakespeare Theatre. Buttz retired on April 17, 1912, after 45 years as a teacher and administrator. He was succeeded by scholarly, patrician Ezra Squier Tipple.

A knock on Tipple's door on January 22, 1928, ended his hopes for success in an ambitious $3 million fundraising campaign just underway to make the seminary into a first-class center of religious education. The knockers were wealthy brothers, Leonard and Arthur Baldwin, longtime Tipple friends and New York City lawyers. The Baldwins had come to give Drew $1.5 million—not for Tipple's campaign, but to endow a new liberal arts college on the seminary campus. Tipple and the university trustees had no room to maneuver. They accepted $500,000 to erect a new two-story, Colonial-style college building, plus a $1 million endowment. In a low-key response to a question on what the college might be named, Arthur Baldwin suggested Brothers College, to express the strong brotherly love the Baldwins had for one another.

Twelve male undergraduates entered the college in September 1928. However, the seminary remained dominant on campus, both in numbers of students and in influence on the trustees, until WWII. The war nearly decimated the campus. Seminarians left to become chaplains and undergraduates enlisted or were drafted. By the summer of 1943, fewer than 40 undergraduates remained, forcing a decision to admit women "for the duration." The first five women entered the college in December 1943. That, plus the assignment of a Navy V-12 contingent to the campus, kept the college afloat. "The duration" for women became permanent in January 1947.

An almost ceaseless period of construction in the nearly 60 years since the end of WWII has dramatically altered both the university's physical appearance and its educational offerings. More than 50 buildings are tucked beneath the towering oaks. These range from a dozen dormitories and apartments for married students to faculty housing; from a three-story science center to the imposing Simon Forum and Athletic Center; from the Methodist Archives to the Learning Center (a huge addition to Rose Memorial Library); and from a large dining center to a spate of structures housing university services.

About 2,000 undergraduates, graduate students, and seminarians are enrolled. The Theological School celebrates its 135th birthday in 2002, and the college turns 75 years old in 2003. An aura of sound scholarship pervades the entire campus. A healthy undergraduate athletic program is divided among nine women's teams, eight men's teams, and a coed equestrian squad. Wearing the university blue and green colors, the teams combine to win well over half of all their contests each year.

In the immediate future lies new building construction that will dwarf the biggest building booms in the university's past. The funding is in place; the future has a rainbow hue. Most importantly, as the future campus emerges, every effort will be made to protect the university's inherited treasure—the mighty oaks. The University in the Forest will endure.

# *One*

# GATEWAY TO A CAMPUS

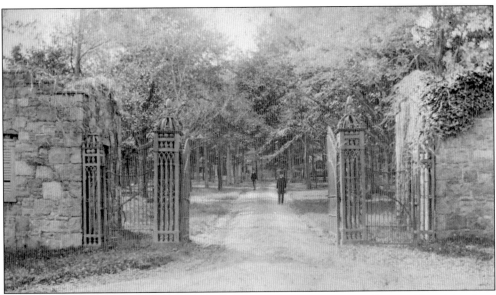

This ornate gateway, constructed in the 1830s, greeted visitors to William Gibbons' Madison estate center, which eventually became the Drew University campus. The men on the shaded driveway are pre-university people. Extending several hundred feet on either side of the gateway is a stone wall erected in the 1830s by area masons. The wall remains in place, but this old entrance was replaced in 1921 by an arched gateway.

Bottle Hill (now Madison) residents felt an almost worshipful regard for the pristine grove of oak trees spread over more than 300 acres just west of town. Old-time residents called it the Forest, capitalized to signify an awe of trees whose green leaves shimmered in spring and summer sunshine and became brilliant red autumn foliage. The oaks made (and still make) a woodland wondrous beyond mere size.

In 1802, Thomas Gibbons (right), known for both shrewdness and obesity, came north from Savannah, Georgia, to acquire half interest in the Elizabethtown–New York ferry rights. His son, William (below), joined his father in 1815, at age 21. When Thomas died, William inherited the Elizabethtown holdings, a fine town house in New York, and about 500 Savannah slaves, each valued at $500 to $1,000. He turned to western New Jersey, where he built hotels in Morristown, a health resort at Schooley's Mountain, and his mansion at Madison.

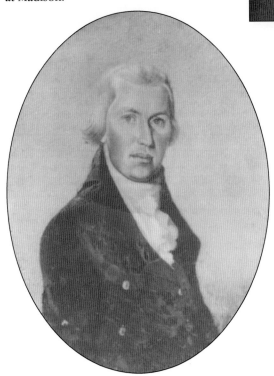

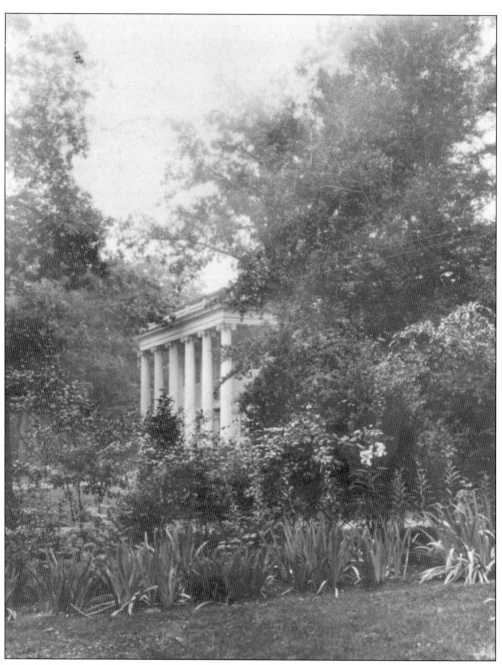

Within the Forest, Gibbons and his wife, Abby, raised a mansion so large that the average village house could fit in the entrance hallway. They reached far for materials—to Santa Domingo for the mahogany in all interior rooms and to England for the stout Ionic front porch pillars. The final cost of $100,000 would represent at least $1 million today, or perhaps double that figure if modern "million-dollar" homes in the area are compared with what Gibbons's money wrought.

While William labored in his first-floor mansion office, insuring that his Georgia slaves made sufficient money to foster Abby Gibbons's expensive tastes, she spent considerable time in New York City buying wallpaper and other household decorations. The bill for papering the house in May 1838 was $630, including 225 yards of gold border that cost $1 per yard. The Wendel room, to the right upon entering the hallway, was refurbished after WWII to emulate the Gibbons period.

Furniture, china, delicate goblets, silver plates, expensive drapes, and oversized furniture were brought to the mansion from Georgia. A canopied bedstead (right), which was in the mansion when furnishings were sold in the 1860s, was bought by nearby estate owner Louis M. Noe. It is still in his family. Gibbons's Savannah foreman wrote him in April 1836: "I congratulate you on the prospect of getting into your splendid establishment."

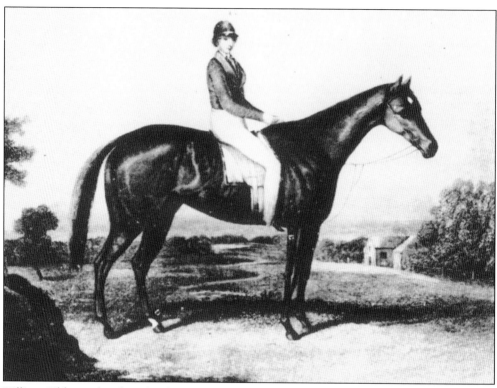

William Gibbons doted on his horses, particularly Fashion (above), called by racing fans the "Queen of the American Turf." Foaled in 1831, she is considered by racing historians to be possibly the best racing mare ever in the United States. The work below, long believed to have been painted "outside a southern mansion," was actually a scene showing the Gibbons mansion steps and one of the piazza columns. The mother and children are not identified, but they are likely Mrs. Gibbons and two of her three daughters.

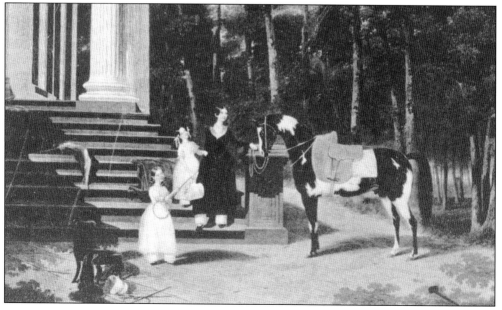

Abby Gibbons was first to die, in October 1844. After a funeral that cost a total of $56.75, which included a mahogany coffin, she was buried in the family plot on the highest hill in the Madison Presbyterian Cemetery. William joined her in 1852; the couple was followed by their daughter, Caroline, and their son, Heyward. The other two daughters are buried elsewhere.

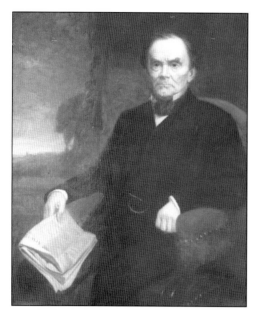
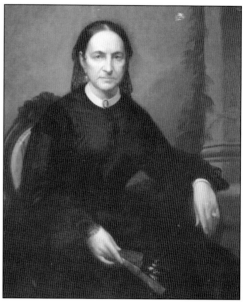

Daniel Drew (left) and his wife, Roxanna Mead Drew, are major figures in the university saga. Both were born in the village of Carmel, New York—Daniel in 1797 and Roxanna several years later. They were married in 1823. By then, Drew was a notable, if shady, dealer in driving cattle from upper New York State to New York City for sale as beef.

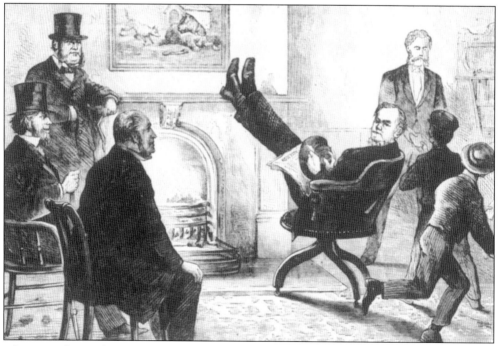

When Daniel Drew fought Cornelius Vanderbilt in 1866 for control of the Erie Railroad, the press reveled in the ensuing bribery, cheating, and fraud. This drawing in *Leslie's Magazine* depicted Drew (with his feet on the mantelpiece) as the "great speculator," dispatching runners to "dump" his shares of the railroad. The battle ruined many little stockholders. Fortunately, Drew already had fulfilled his pledge to underwrite a new Methodist seminary.

OLD HOMESTEAD OF DANIEL DREW.

Daniel Drew received full attention from popular publications of the period. The public wanted tales of his boyhood in the Mount Carmel, New York home (left), as well as tales of his financial transgressions on Wall Street—even as he dug deep to provide money to establish Drew University (right). The daily adventures of his steamboat, the *Daniel Drew* (below right), led to this popular lithograph.

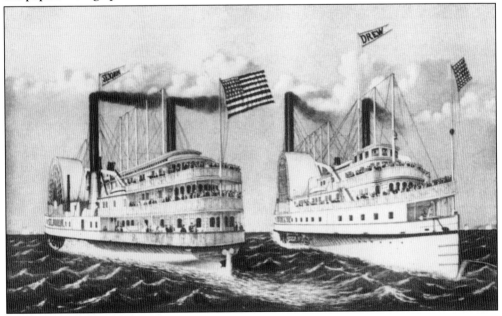

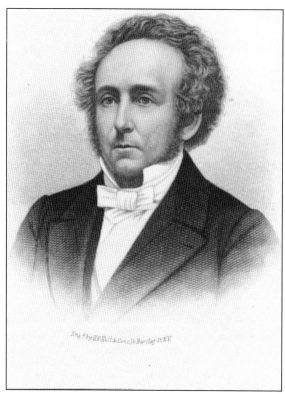

Despite a constant series of illnesses and occasional overpowering bouts with hypochondria, Rev. Dr. James McClintock (left) was the leader that Drew Theological Seminary needed when it opened its doors in the fall of 1867. He was well educated, had a close relationship with Daniel Drew, and believed in educated ministers. When McClintock welcomed the leading lights of Methodism to the impressive opening ceremonies (below) in the great hall of the former Gibbons mansion on November 6, 1867, an artist from one of the popular magazines of the day was on hand to give not only a view of the opening ceremonies, but a lasting image of the hall as it looked in 1867.

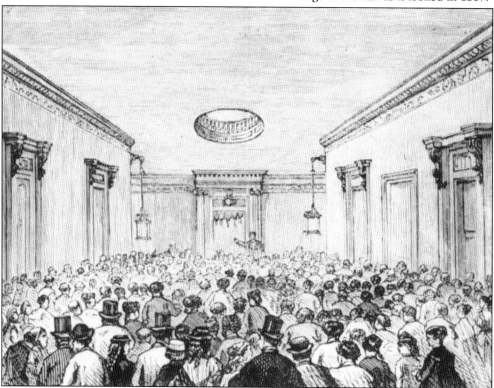

# Two

# THEOLOGY
# UNDER THE OAKS

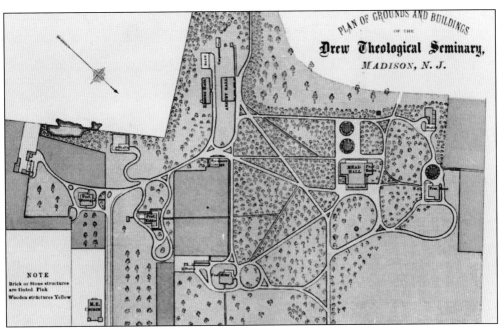

PLAN OF GROUNDS AND BUILDINGS
OF THE
Drew Theological Seminary,
MADISON, N. J.

NOTE
Brick or Stone structures
are tinted Pink
Wooden structures Yellow

Drew Theological Seminary's first class of nine men graduated on May 29, 1869. They were saddened, however, by the awareness that their once dynamic seminary president, Dr. John McClintock, was very ill. He died on March 5, 1870, knowing he had gotten the young school off to a solid start. By the 1870s, when this map was drawn, the campus had 12 buildings, including three stables and a barn. Roads and pathways had been cut through the once dense woodland, but the mapmaker recognized that the seminary lay under a canopy of leafy oak limbs. Since this map was drawn, the campus has spread widely to the west and southwest.

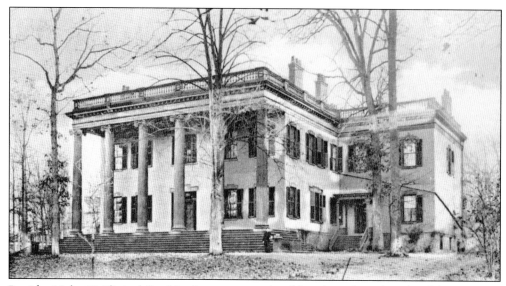

President John McClintock lived in the two-story wing (above) on the right side of the mansion, called Mead Hall. It was highly convenient; in bad weather, the president could step through a door and be in the middle of classrooms and the library. Daniel Drew built four faculty houses in 1868, including a home for the president (below). A very short walk from the president's office, the roomy, comfortable home with the mansard roof and wraparound porch housed presidents until 1956, when a modern home was built some distance from Mead Hall.

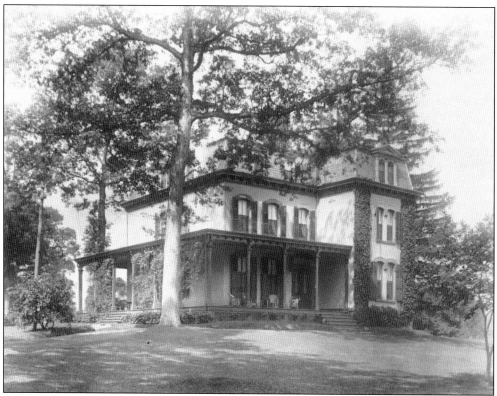

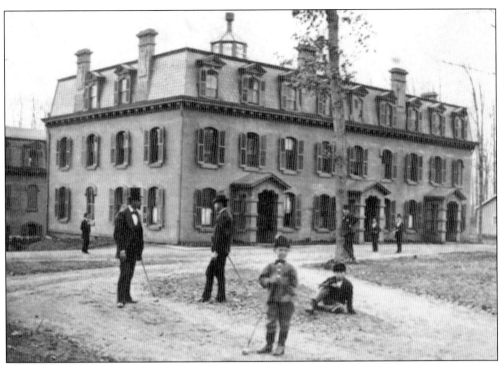

Student life and studying were centered in the three-story Asbury Hall, an ingenious revamping of the stable where William Gibbons had kept about 25 of his thoroughbred race horses. Daniel Drew provided the money to create 73 badly needed dormitory rooms in the erstwhile stable, c. 1868. There were three front entrances, and multiple dormers in the mansard roof let air and sunlight into third-floor rooms.

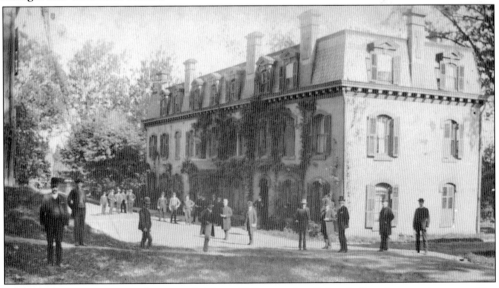

Embury Hall, a granary at the rear of Asbury Hall, was the dining hall and recreation area. The dining room was where students ate, argued, philosophized, planned menus, and allocated the work of buying and cooking food. Dining was student operated, but complaints about the food and cost were little different from those of every generation to follow.

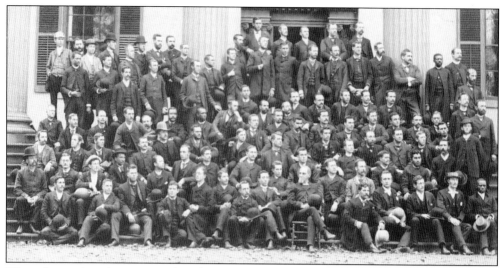

When the seminary's entire student body convened on the front steps of Mead Hall for this 1875 picture, Drew's national and international appeal had begun to emerge. Students had matriculated from nearly every state, from Canada and South America, and from such Far East nations as India, China, and Japan.

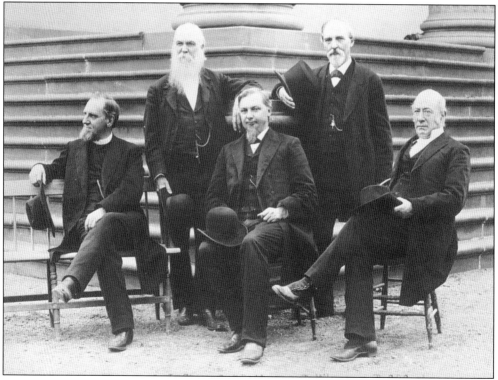

Powerful in educational backgrounds and in teaching ability, this group of Drew professors was known throughout the Methodist Church of the 1880s as the "Big Five." All of them had earned Ph.D. degrees and were known far beyond the campus through their writings and speeches. They are shown here, from left to right: Samuel F. Upham, James Strong, Henry Anson Buttz, Dr. John Miley, and George B. Crooks.

Drew lost its second president, Randolph Sinks Foster (left), and its third, John Fletcher Hurst, within three days in March 1903. Foster died on May 1 at age 69. Hurst died three days later. Each played a major role in shaping the seminary. Hurst is credited with saving the institution when Daniel Drew's fortunes collapsed to the point that he had even lost the seminary's endowment.

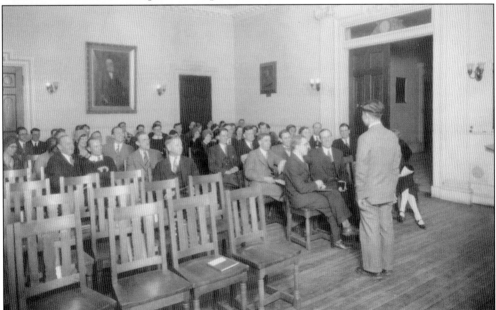

Homiletics, the art of preaching and writing sermons, has always been a vital study for clergymen-to-be. Here, in a Mead Hall classroom, *c.* 1910, an obviously nervous student stands ramrod-stiff as he delivers a practice sermon. The women in the class might have been faculty wives or among those permitted to audit courses as special students.

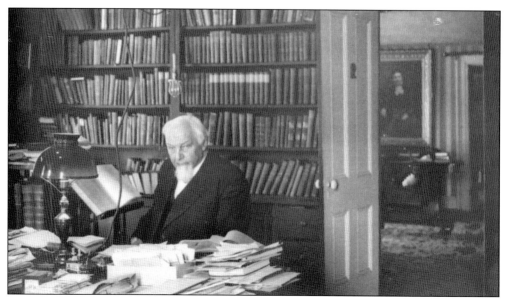

No one has surpassed Henry Anson Buttz's contributions to Drew. Educated at the College of New Jersey (now Princeton University), he came to Drew in 1867 to teach Greek. He became the fourth president in 1880 and remained until he resigned in 1912. He built and maintained a strong faculty and completely revamped the campus by building five substantial stone or brick buildings. He died in 1920 at age 85. Townspeople joined faculty, students, and trustees in mourning the fallen leader.

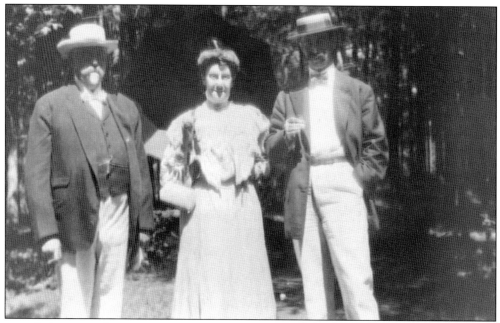

Buttz had a genius for making and keeping friends, many of whom became substantial givers to the seminary. A leader among those friends, Samuel W. Bowne, earned remembrance in Hoyt-Bowne Hall, but his contribution of Bowne Gymnasium (now disappeared into the Kirby Theatre) and his underwriting of Samuel W. Bowne Hall (known as the Great Hall) have been nearly forgotten. Bowne (left) appears here with his wife, Nettie, and friend Edward Hewitt Coburn Jr.

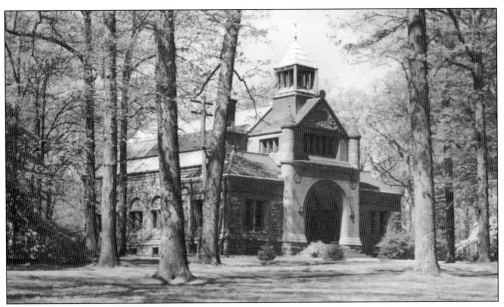

Named for principal donor John B. Cornell, the Romanesque red stone Cornell Library (above) was opened in 1886. Cornell, a trustee, donated about one-third of the funds needed for the structure, built to contain 40,000 volumes. Buttz had it built midway between classrooms in Mead Hall and dormitory rooms in Asbury Hall. Cornell died before the library was finished. In 1890, Mrs. Cornell installed a striking round stained-glass window, 9 feet 6 inches in diameter. It was called the "Rose Window," because its features emanated from the center like a rose. It can be seen at the top of the interior photograph (below).

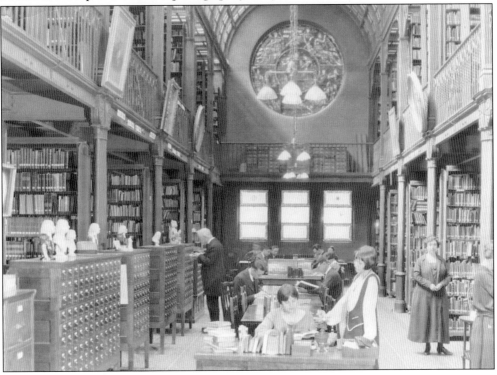

Organized, although never intercollegiate, athletics began in the fall of 1888 in a small wooden gymnasium adjacent to Embury Hall. It is visible behind the automobiles on the right side of this photograph. Sports picked up the physical pace in autumn football games on the broad lawn behind Hoyt-Bowne Hall. The games were limited by the relatively small enrollment. Football

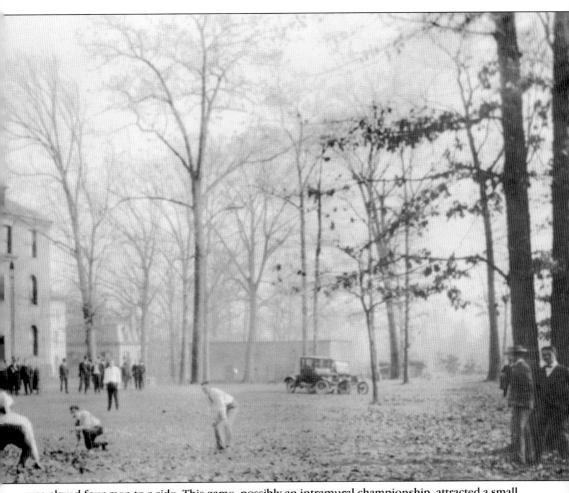

was played four men to a side. This game, possibly an intramural championship, attracted a small crowd. The photograph was taken *c.* 1910, a date based on the automobiles and the fact that Bowne Gymnasium was not opened until 1910.

After the invention of basketball in 1891, most higher educational institutions saw the wisdom of a modern gymnasium. Drew did not lag much. Bowne Gymnasium, named for liberal contributor Samuel W. Bowne, opened in 1910. For $30,000, Bowne's money paid for a basketball court, an indoor running track, a swimming pool, showers, lockers, and gymnastic equipment. This view of the gym was taken *c.* 1925.

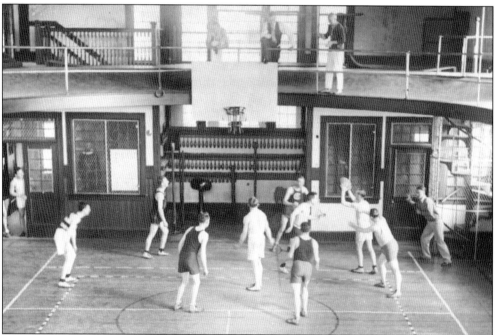

The gymnasium's chief drawbacks were its small size and the indoor track that overhung the floor on all four corners. Visiting players found their shots from any corner ricocheting off the bottom of the track. Spectators at games crowded into portable chairs arranged around the balcony.

When Hoyt-Bowne Hall was dedicated in October 1893, Bishop John F. Hurst, Drew's third president, returned to campus and, in his formal address, wondered if the rooms (above) might be "a trifle too comfortable." That comfort had cost $100 per room for furnishings that included an enameled bed and an oak dresser. A student of the 1890s (above), enlivened his room with decorous pinups, when the rooms were comparatively new. His counterparts in 1920 (below) undoubtedly wondered at the increasing shabbiness of the rooms. In either case, the upright Remington typewriter remained as standard equipment.

The last and greatest of the campus buildings attributed to Henry Buttz was the grey granite refectory patterned after Christ Church Hall at Oxford University, where John Wesley and other pioneering Methodists had dined. Samuel Bowne had provided for the structure in his will; the building properly was named for him. This image shows the western end of the monumental building, which is 135 feet across the front. Dormitories were built on the first floor, and the huge dining room on the second floor had facilities for all students and professors to have regular meals. Students dined there from 1913 to 1960. The refectory is now the home of the Casperson School of Graduate Studies.

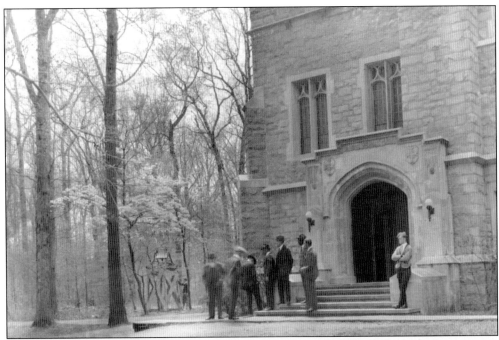

This Gothic arch of the Great Hall (above), through which thousands of students have entered, led to broad inside steps that led up to the awe-inspiring room, 85 feet long, 33 feet wide, and 39 feet to the tip of the slanted ceiling. Seven leaded stained-glass windows (below) let in light on either side of the dining hall. Supplemental light came from 12 large chandeliers suspended from the ceiling on long chains. In this room, the Drew community gathered for daily meals as well as social events and other major campus happenings.

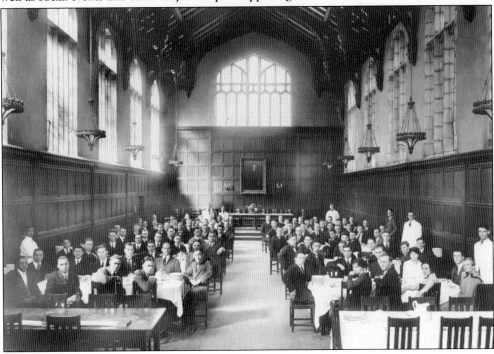

Before proceeding across campus for the laying of the cornerstone of the Samuel W. Bowne refectory on October 24, 1912, trustees and friends gather in front of what was then known as the seminary building. Those shown make up a small portion of the gathering on campus. It was to be a day of double celebration: the laying of the cornerstone of Drew's splendid new building and the inauguration of Ezra Squier Tipple as the university's fifth president.

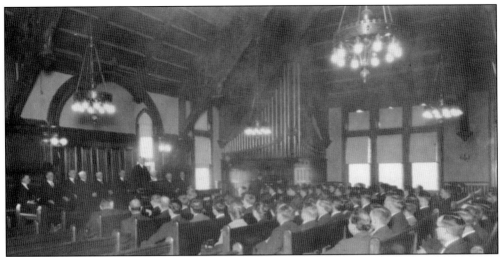

One of the chief blessings of the seminary building was the chapel on the second floor. Fifty-eight feet long and 38 feet wide, the chapel could accommodate 600 people. Chapel services were held at 8:30 a.m., Tuesday through Friday. The chapel provided an inside auditorium for commencements, although the poorly ventilated space could be brutally hot and sticky on a rainy midday in May.

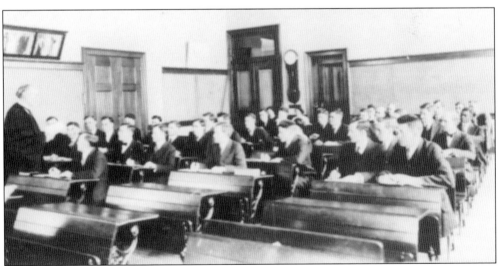

The large formal classrooms in Seminary Hall gave lectures and class discussions a classical formality that could not be achieved when classes convened in Mead Hall rooms. Here, more than 30 students listen raptly to a lecture in Hebrew by Prof. Robert William Rogers. He taught Greek and Hebrew and was an internationally respected scholar—perhaps Drew's most prestigious teacher.

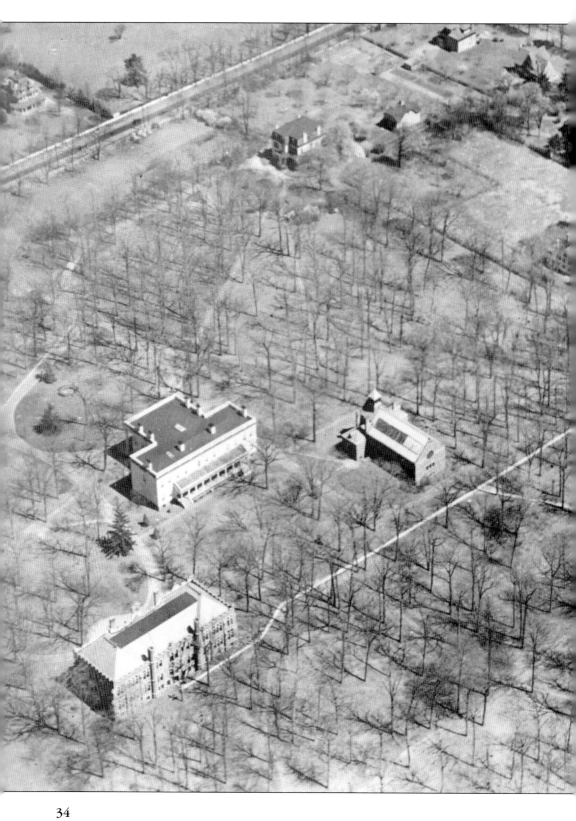

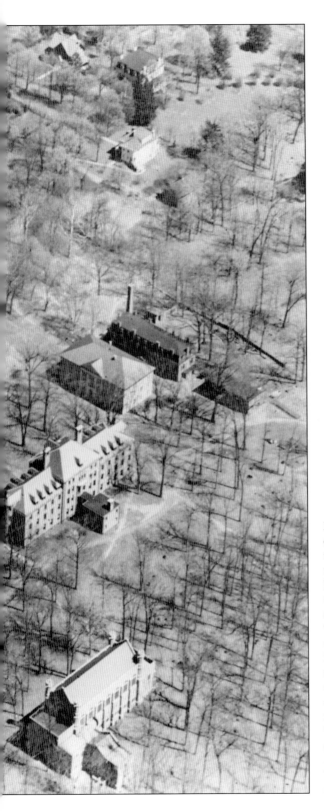

Four of the five buildings built during the Buttz regime appear in this springtime aerial photograph taken in the early 1920s. The fifth building (not shown) was Bowne Gymnasium. The seminary building and Cornell Library are behind T-shaped Mead Hall on the opposite page. The Samuel W. Bowne refectory is on the bottom of this page. Immediately above the refectory is the Hoyt-Bowne dormitory. Buttz had taken the inadequate campus of Drew Theological Seminary and built it into a substantial entity—and the impressive building program had been accomplished with minimal damage to the Forest.

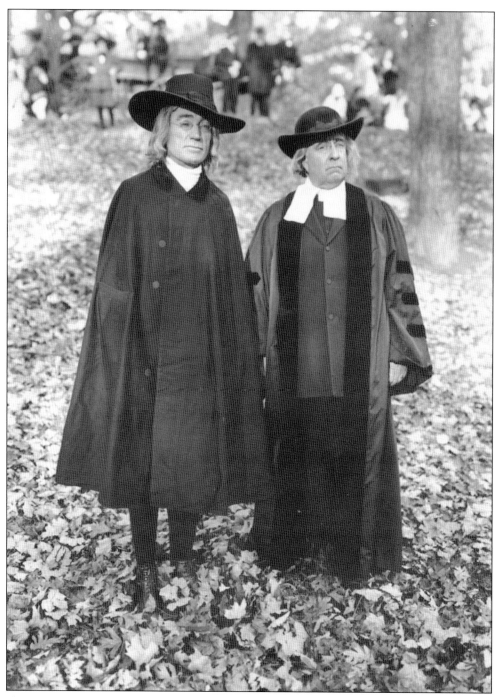

The seminary celebrated its 50th anniversary in 1917 with a memorable pageant of Methodist history. Professors W.I. Haven (left) and John Faulkner portrayed two of the earliest American Methodist leaders, Thomas Coke (Haven) and Francis Asbury (Faulkner). Coke and Asbury were in the forefront when the Methodist Episcopal Church in the United States was founded on Christmas Eve 1784.

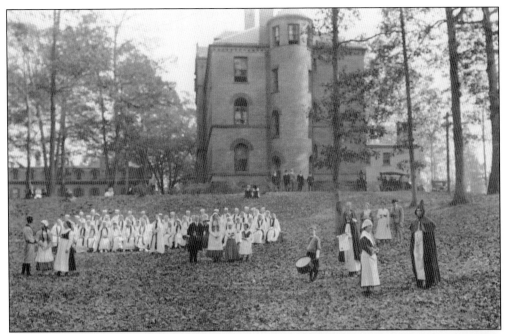

A drummer boy called the proceedings to order and a white-gowned chorus sang its opening song in the 1917 pageant. It took place on the slope behind Mead Hall and to the side of Hoyt-Bowne Hall, which looms in the background. The pageant concentrated on all American Methodist history, although considerable time was spent on John Wesley, who with his brother Charles, founded the Methodist Church.

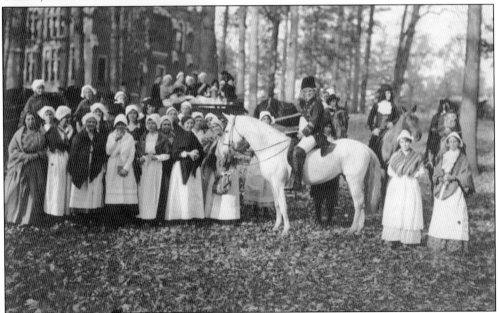

T.T. Crawford, mounted, portrayed the great early Methodist circuit rider Capt. Thomas Webb, a former British army officer who lost an eye during the French and Indian War. After the injury, he traveled widely to carry an evangelical message to people in emerging villages or on scattered farms. He paved the way for Francis Asbury, who was the greatest of the circuit riders.

For several decades, faculty wives and a few student wives were the only women on campus. In 1915, when spouses of 13 Drew Theological Seminary faculty members posed for this open-air photograph, they ranged in age and style of dress from a few who were quite young to most who were definitely the reigning matrons.

Women were first admitted in 1919 as regular students "on the same basis of scholarship as men." Esther Turner Wellman, wife of a seminary student, enrolled and, in 1921, received the first Drew Bachelor of Divinity degree awarded to a woman. The class above, being taught in Mead Hall sometime in the 1920s, was likely one in the College of Missions that was most attended by women.

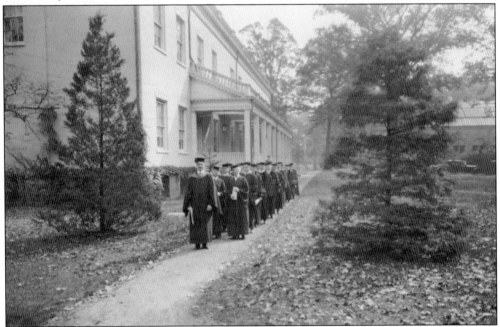

On October 24, 1922, when the faculty lined up (perhaps for the annual Founders Day convocation), its size was impressive. Fifth president Ezra Squier Tipple's determination that Drew must become one of the nation's finest theological schools led him to enlarge class offerings and to strengthen the quantity and quality of the faculty. He prepared to launch a major $3 million fundraising campaign as the 1920s began.

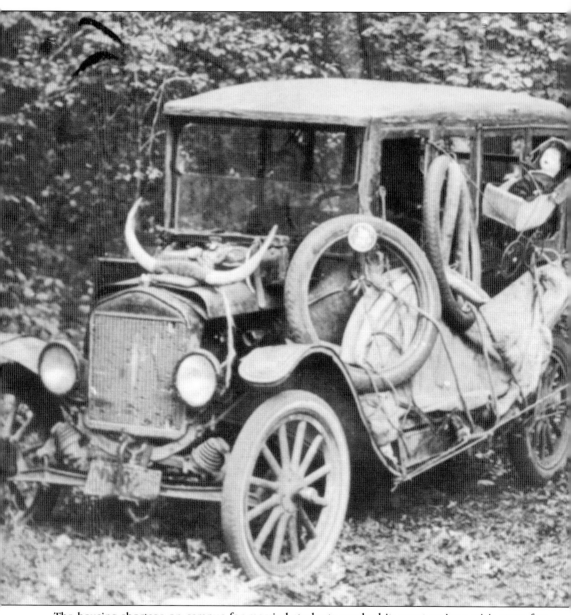

The housing shortage on campus for married students reached its most serious crisis stage for this seminary student, his wife with her babe in arms, and their small twin girls. The tiny tent was the family bedroom and his study hall. The vintage Ford car, with horns strapped to its hood, was presumably their storage area in addition to a vehicle to carry him to weekend pastoral duties or

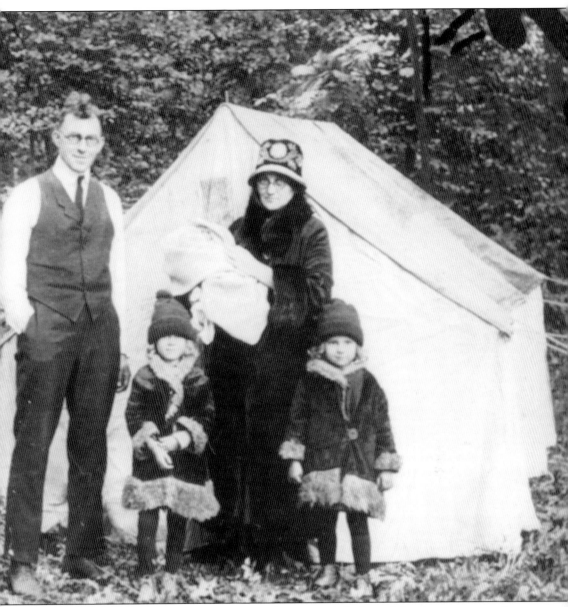

for the family to flee the campus for short intervals. It can only be hoped that there was room for them in the dining hall. Nothing is known about the couple; if he earned his degree, it would have been a minor miracle.

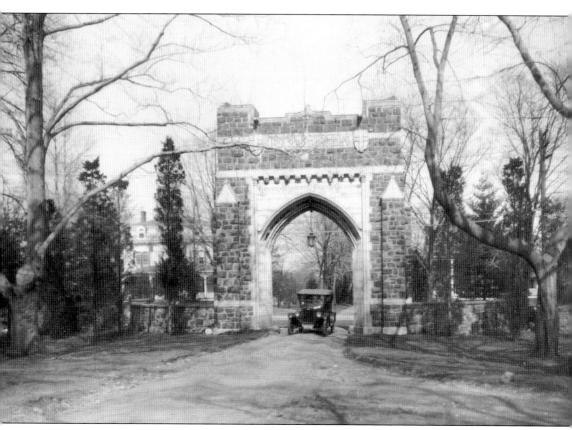

Despite student and faculty protests that the original Gibbons gateway built in the 1830s should be preserved, the trustees replaced the outmoded antiquity with the high new archway in 1921. It was dedicated on the 150th anniversary of the arrival of Bishop Francis Asbury in America. For nearly two decades, the archway permitted automobiles to enter the campus on a narrow, one-lane road.

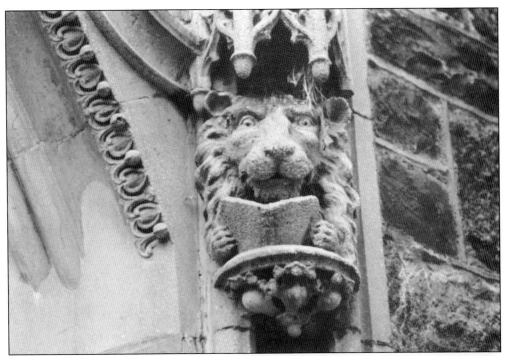

A few of the many symbols of the gateway arch include the lion (above) with a Bible, which represents the courage and loyalty themes found in St. Mark's gospel. On the left (below) is the sweet innocence of a cherub. On the right, an imp wearing a stocking cap with a tassel provides comic relief. The cap is a freedom cap and the tassel is associated with a student's cap and gown.

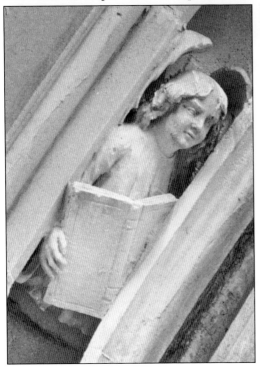
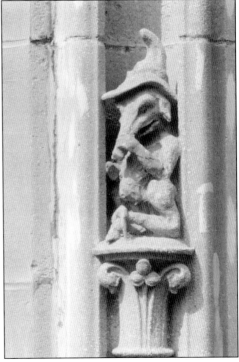

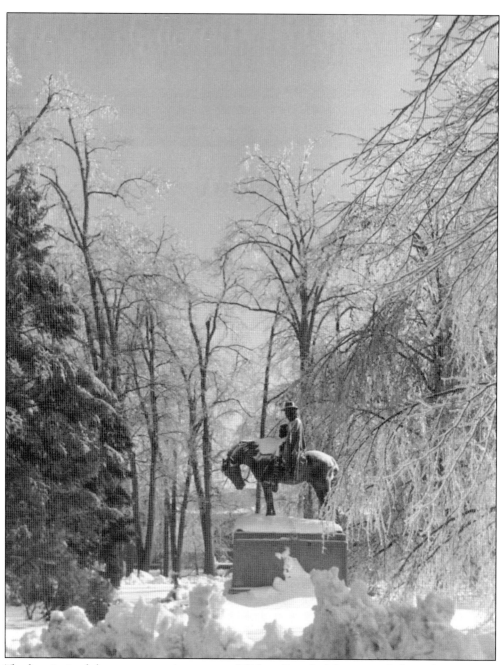

The heroic-sized, bronze equestrian statue of Bishop Francis Asbury was dedicated on campus on October 14, 1926, in the name of Edward S. Pilling, Drew Class of 1885. It could also be seen as a tribute to Drew president Ezra Squier Tipple, Asbury's chief biographer. His *Life of Francis Asbury*, published a decade before, was a vivid depiction of the rugged existence of "the Prophet of the Long Road."

# *Three*

# COLLEGE OF
# BROTHERLY LOVE

Leonard and Arthur Baldwin,
brothers and highly successful New
York City attorneys, changed the
course of Drew University in January
1928, when they gave the institution
$1.5 million to found, build, and
endow a liberal arts college on the
campus. Their brotherhood was both
unique and enduring. They went
to Cortland (New York) Teachers
College together. They studied
law at the same time, established a
law partnership in New York City,
married sisters, and lived together
with their wives and children in the
same house in East Orange, New
Jersey. They asked that the new Drew
building be called Brothers College to
commemorate their love and respect
for one another. The first class of 12
male freshmen arrived in the autumn
of 1928. Nearly two years would pass
before the first sounds of Westminster
chimes would peal from the clock
tower atop Brothers College.

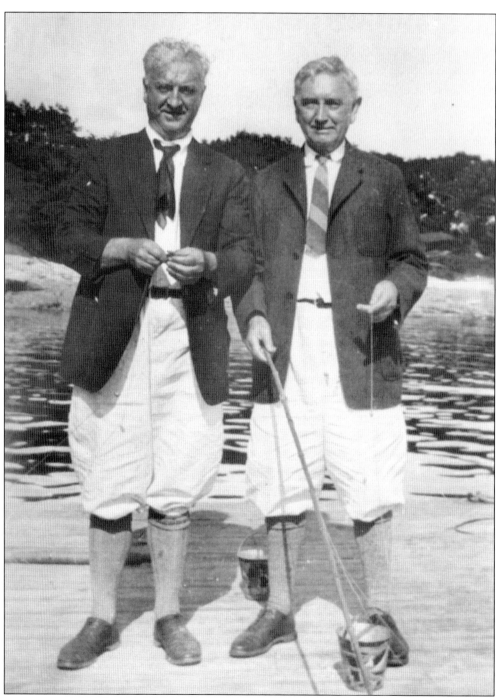

Arthur (left) and Leonard Baldwin took brotherhood far beyond their law office, the home they shared in East Orange, New Jersey, and Drew University. Each summer they and their families (including grandchildren) spent as much of each summer as they could afford at their cottage in Boothbay Harbor, Maine. Here, they are shown in relaxing clothes, including the knickers popular in the 1920s. A grandson has said, "It can't be told from the photograph whether they planned to fish or play golf."

The first class of freshmen (above) gathered around the Baldwin brothers on groundbreaking day in September 1928. The incoming group met for classes in seminary facilities; most of their professors were from the Theological School or were recent alumni of that school. When the Brothers College building (below) was dedicated on October 17, 1929, the second class of 21 new freshmen was enrolled, giving the college a total of 33 students. The first class still numbered 12; two of the original students had dropped out, but two transfer enrollees had replaced them.

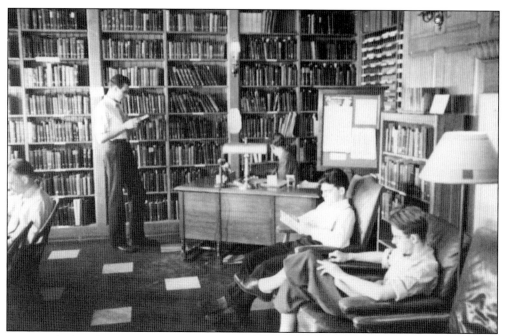

Entering the building from the rear courtyard that faced the major portion of the campus, a cozy Brothers College library (above) was on the right, where the Korn Art Gallery is now located. Professors "ordered" books for their disciplines from the main university library, and had them placed on college shelves for exclusive use by students. The library also served as a convenient study hall, either at the long tables throughout the room or in comfortable chairs in front of the fireplace.

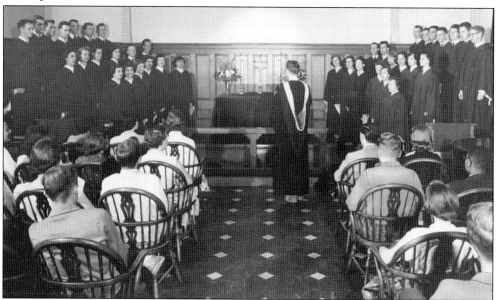

Across from the library is the college chapel. This view, taken sometime after women students were admitted, shows men and women students about equally divided. There was no compulsion to attend chapel; by 1932, less than half of the college students were Methodists. Friday evening dances, with music supplied by records, were often held in the room.

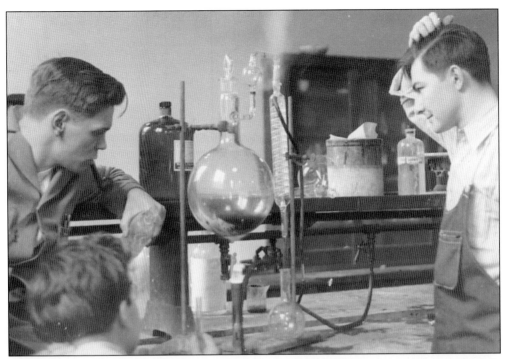

Science classrooms and laboratories on the lower floor provided facilities that initially met all needs of the liberal arts college. The college hired leading biology, chemistry, and physics professors, whose abilities attracted ever increasing numbers of students. By WWII, the college's science graduates could be found in many of the area's chemistry and pharmaceutical laboratories.

The Drew Foresters struggled to stay alive, using small space to produce big effects. Its plays included several ambitious presentations for the period, as well as Gilbert and Sullivan operettas. Since the college was all male, actresses had to be found among university employees. In one case, all characters were enacted by non-college students, creating an uproar that forced a change.

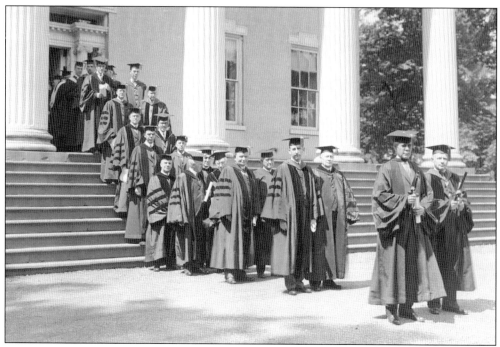

President Ezra Squier Tipple (second row, right) passed the presidential baton to his successor, Dr. Arlo Ayres Brown (on Tipple's right) at commencement in May 1929. Brown, Class of 1907 in the Theological School, fitted trustee hopes for a president who would be "seasoned, experienced and mature of judgment," yet "young enough to be in touch with student life and the prospect of some decades of activity before him."

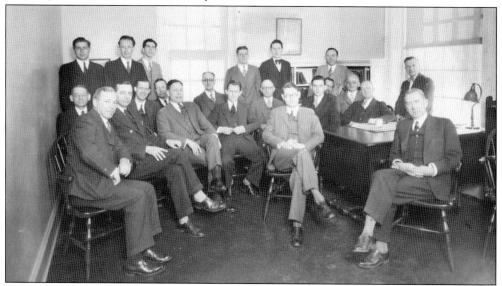

The 22 members of the Brothers College faculty pose for this group photograph during the 1931–1932 school year. The group had several professors who would have long tenure on campus, including Professors Young, Green, McClintock, Harrington, and Jones. Dean Frank G. Lankard served first as professor of the Bible. Then, for 20 years, Lankard was the compassionate dean of the college.

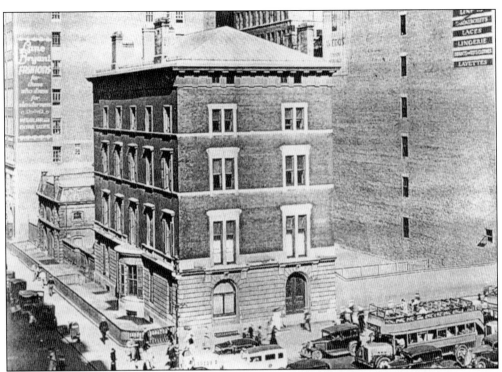

The press-named "House of Mystery" on New York City's prestigious Fifth Avenue was where the mysterious Wendel family lived from 1856 until March 13, 1931, when the last of them, Ella Wendel, died in her sleep in the mansion where she had lived for 75 of her 78 years. Newspaper estimates of her wealth hit $150 million, which was subsequently trimmed, but Drew University received about $5 million, plus the Wendel mansion set on one of New York City's most valuable pieces of real estate.

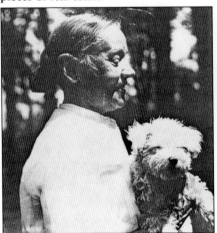 

Ella Wendel, the last of her family, is pictured (left) with one of her dogs, Tobey. Her major affront to New York society and the press seemed to be that she minded her own business, as did the Wendel son and his seven sisters who lived much of their lives cloistered in the strange house on one of New York's busiest corners. When the Wendels vacationed, they eschewed such fashionable resorts as Newport, preferring this small cottage on family property in Tarrytown, New York.

Hoyt-Bowne Hall on the left and Asbury Hall, center, were the major dormitories on campus when Brothers College was opened. The college appears in the distance, framed by the dormitories. Behind Asbury Hall on the far right is Embury Hall, the one-time dining room and social center of the seminary.

At the time of this photograph, showing the interior of Asbury Hall, the building was a dormitory for Brothers College students. A typical room, such as this one, was very comfortable. Perhaps the frilly curtains would not have appealed to modern student tastes, but the decorated walls and the number of students crowded into the room would be normal for any generation.

While automobiles were not numerous on campus during the Great Depression of the 1930s, there were enough parked on the road between Hoyt-Bowne and Asbury Halls to create an aesthetic problem. Most of them likely belonged to the theological students who resided in Hoyt-Bowne. They needed transportation when they went off on weekends to serve as supply ministers in small New Jersey churches.

One of the original faculty homes built by Daniel Drew, the so-called Rogers House became a prime residence for undergraduates. The building, named for Hebrew professor Robert William Rogers, was razed in 1966 to make way for the new science hall. Adjacent to the college building, Rogers House became a center for socializing, philosophical arguing, and just plain relaxing in the sunshine.

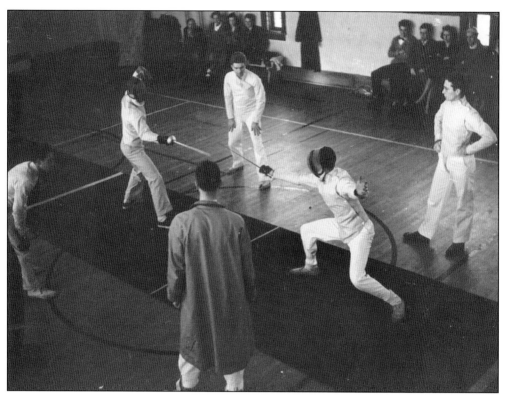

Varsity sports began in the 1929–1930 year. Basketball was first, followed by baseball, fencing, and tennis. Some of the teams, such as fencing (above), were started by and initially coached by students. Athletics were considered to be part of the educational program, with strict academic regulations governing eligibility to play. Baseball quickly became the major sport under the coaching of Greek and Latin professor Dr. Sherman Plato Young. His 1937 team (below) posted one of the best records in history.

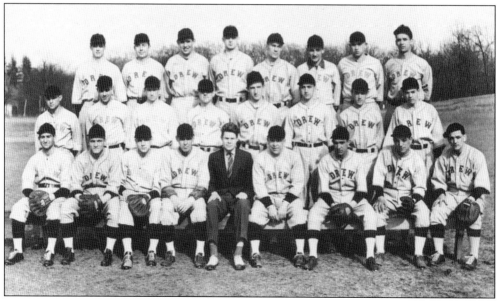

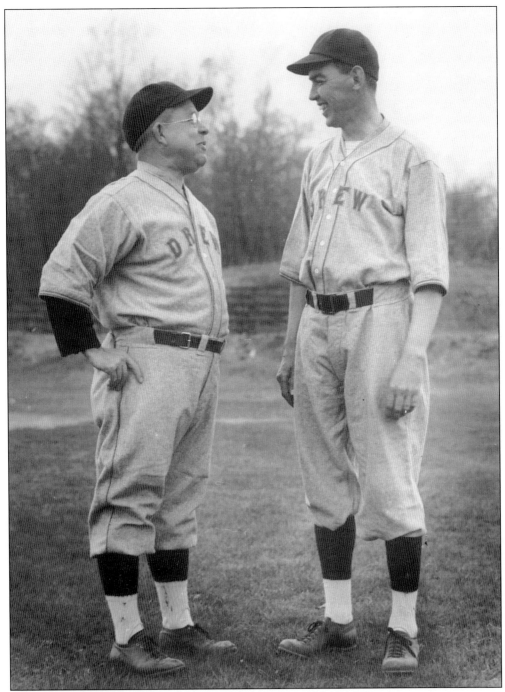

Drew's famous athletic duo—Dr. Sherman Plato Young, baseball coach, and Harry W. Simester, director of physical education and basketball coach—was formed in the autumn of 1935, when Simester arrived on campus. The two mentors became warm friends and cooperated smoothly in athletics. Drew entered a fine era of success on baseball diamonds and basketball courts.

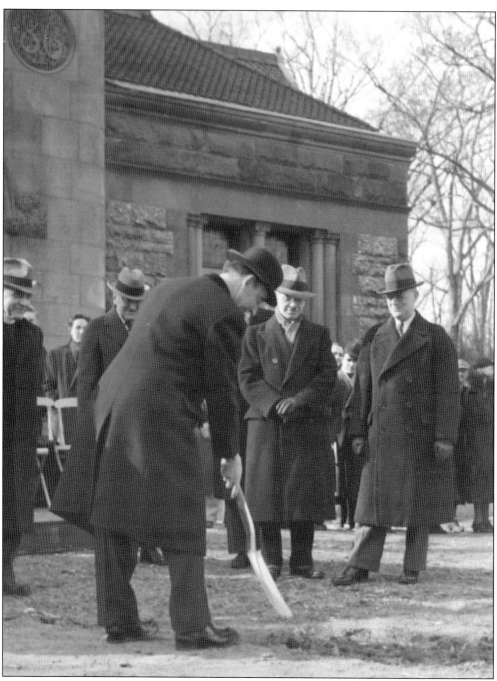

On May 6, 1937, the campus was electrified by news that Lenox S. Rose, a wealthy Newark leather manufacturer, had willed the university $500,000 for a new library as a memorial to his wife, plus $1.5 million for scholarship grants. The library would be named Rose Memorial Library to honor Nellie Rose. President Arlo Ayres Brown dug the traditional first shovelful of dirt on January 28, 1938, to get the library on its way. Looking on were O. Gerald Lawson, librarian, and Frank G. Lankard, Brothers College dean. Cornell library, partially visible behind the ceremonial dig, continued functioning until the new library was finished.

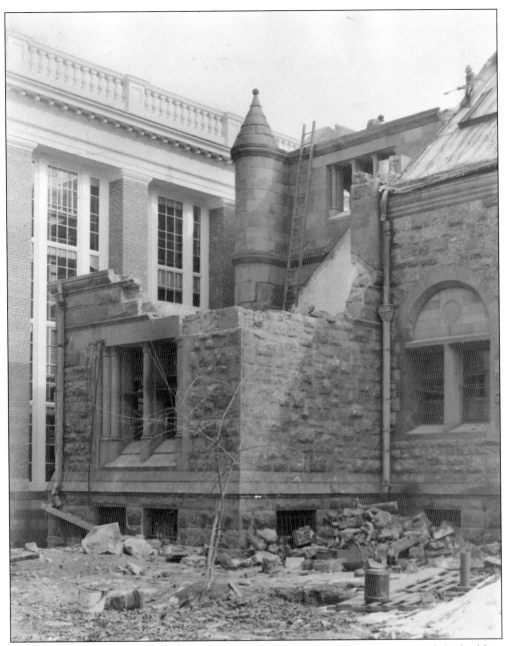

Old Cornell Library's front doors closed during construction and students entered the building via a new rear door. Finally, as the new library neared completion, wrecking machines came and made short work of the solid old historic structure. In this photograph, one of Cornell's turrets stands starkly outlined by the new library.

Shaded by the oak trees and beautified by flowering dogwoods, Rose Memorial Library opened for full use on February 1, 1939. It had taken only a bit more than a year from groundbreaking to the opening of the doors. When the last book was transferred from old Cornell Library, it was leveled and the debris was carted off to the rear part of the Forest. Rose Library had three levels of reading rooms and six open stacks that contained more than 200,000 books. The shelves had a capacity of 400,000 volumes.

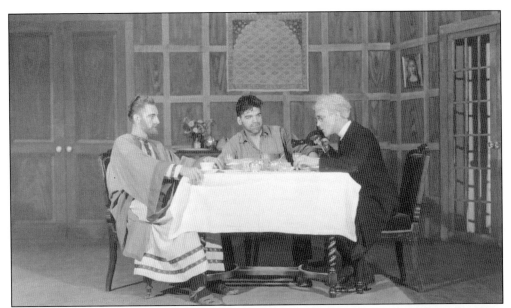

Student life went on. The Drew Foresters, founded in 1929, were a full-fledged group when it presented *A Servant in the House* in December 1936. The veteran Brothers College student actors shown, from left to right, are Frederick Weihe, Wilfred Hansen, and Ernest Arthur. The production was staged on three nights on the spacious stage of nearby Madison High School.

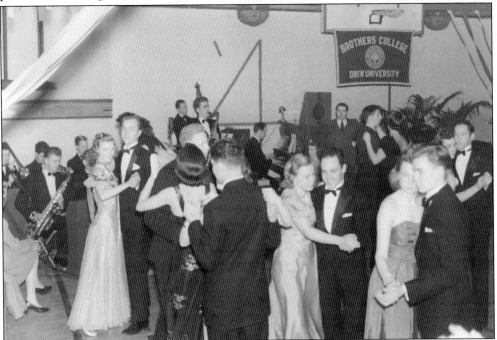

Formal proms each spring and fall established an enduring tradition in the early 1930s. They were held at first in the Great Hall, where the huge decorated dining room provided ample space for students and their dates from hometowns or downtown Madison. However, the 1940 prom pictured shown here was held in the comparatively bleak Bowne Gymnasium. Note the backboard and basket at the top.

The 13 candidates for graduation from Brothers College at the 1943 commencement were symbolic of the dire days that faced both the nation and the university. Seventeen members of the class were in uniform. There was ample reason to believe the college might have to suspend operations for the duration. Because of the youth of its graduates, 70 percent of Drew alumni entered service, likely a record unmatched by any other university.

# *Four*

# A WAKE-UP CALL

Wartime changed the face of the campus. From the rationing of supplies and the nightly air raid patrols to the departure of faculty for distant shores, the idyllic University in the Forest was no more. Indeed, with seminarians heading off as chaplains and college men trading letter sweaters for fatigues, not many were left to pay the modest tuition that kept the school in business. The empty coffers sounded a wake-up call to the powers that be. Sailors like this one eventually helped answer that call.

Despite some grousing from the male student body still on campus, the trustees found a way to stay in the black. In November 1942, they heeded the faculty's call for "properly qualified students" of any gender and admitted women "for the duration." Realizing history was being written and unwilling to declare one "first coed," dean Frank Lankard decided the four women who applied that December each held the distinction. Early coeds, like those pictured, lived off campus since a dormitory was not yet set aside for them. But their motivation was certain; they were there to earn B.A. degrees, not Mrs. degrees.

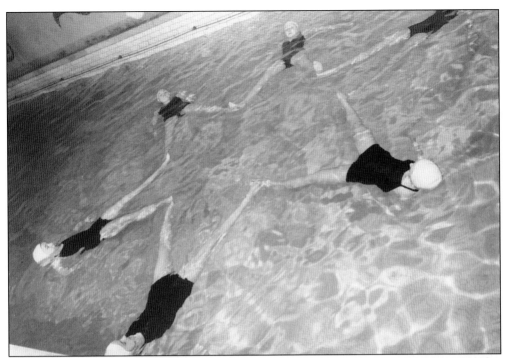

The "skirts," as they were called, brought more than a new look to campus, introducing extracurricular activities tailored to their own interests. In bathing caps and swimsuits, the "synchers" treaded the often murky waters of the Bowne natatorium to perform water ballet.

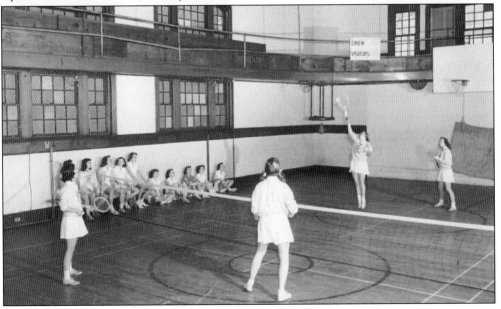

Basketball players yielded the gymnasium floor to badminton contests. The smart man took this opportunity to run a few laps on the track above. The trouble was, not many men were still around. The call to arms had left fewer than 35 male undergraduates in the classroom, and the few women who accepted the school's tepid welcome were not enough to bring enrollment up to prewar standards.

The military was scouting out campuses for training enlisted men, but Brothers College was initially passed over because it could not accommodate the numbers they were looking to place. You can imagine the tremendous sigh of relief when the U.S. Navy reconsidered its criteria and selected Drew as the port of call for 200 sailors. The V-12 unit stormed the campus much like Normandy, making its mark immediately.

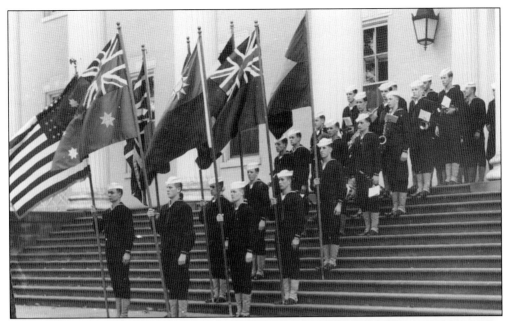

The sailors, like these men in line for a flag ceremony at Mead Hall, not only brought a glamorous, worldly dimension to the university, but their own lingo and regulations as well. Campus doors were rehung to open outward. Windows became "ports" and floors "decks." Held to a strict schedule, trainees rose promptly at 6 a.m. to the sound of a bugle and adhered to lights out promptly at 10:30 p.m.

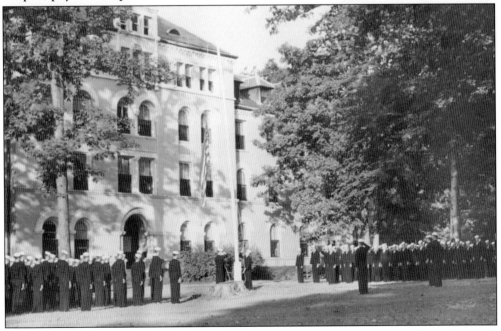

That clockwork precision was followed throughout the day. Ten minutes after rising each morning, the sailors stood at attention for the flag raising in front of their dormitory, which they christened the USS *Hoyt-Bowne*. Breakfast followed 30 minutes later, clean-up precisely 35 minutes after that, inspection a half hour later, and, finally, dismissal to attend class.

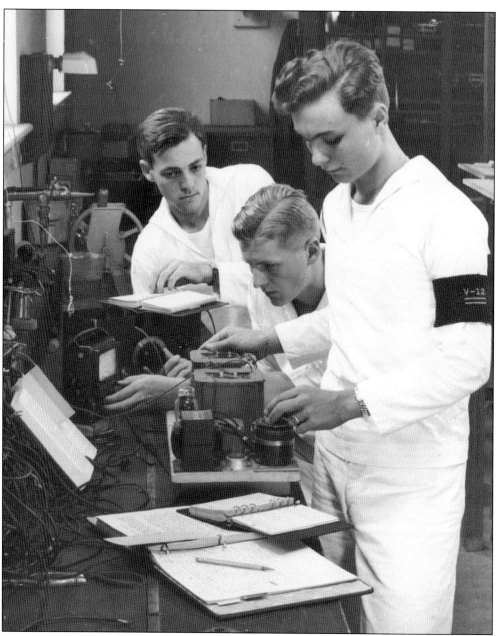

Academics, like everything else, was serious business for the "whites," as these sailors in physics lab would agree. All were eager to complete their basic training and get to midshipman school and eventually become commissioned ensigns. None wanted to end up at boot camp because of poor grades, but Drew standards were high and professors gave no special breaks to anyone, even those committed to defending our country.

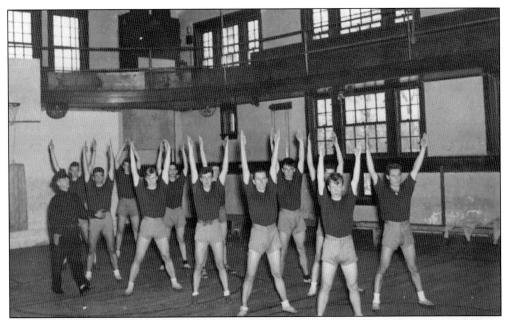

To become trainees, the men were held to particular physical standards that extended to having "20 vital serviceable teeth," according to *Sunday Call* magazine. Once in training, those standards never slackened. Here, the commanding officer puts his sailors through their paces in Bowne Gymnasium. Basketball coach Harry Simester certainly did not mind turning the gym floor over to the U.S. Navy. The V-12ers led his team to a 14–3 record in the 1943–1944 school year.

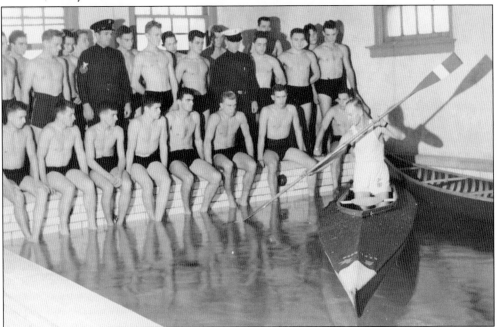

From water ballet to foldboat maneuvers, the Bowne pool saw a lot of action during wartime. Here, as part of a Red Cross functional swimming event, fledgling seamen watch instructor James Cawley demonstrate the proper handling of the *Explorer*, a collapsible boat carried on submarines. You can be sure that no synchers were on the premises to distract them.

At ease in front of Brothers College, these sailors were likely on their 90-minute lunch break. In class, typically from 8 a.m. to 4:30 p.m., the trainees had to put in another two and a half hours each night studying. Falling behind in their studies meant no liberty on weekends to fraternize with female students.

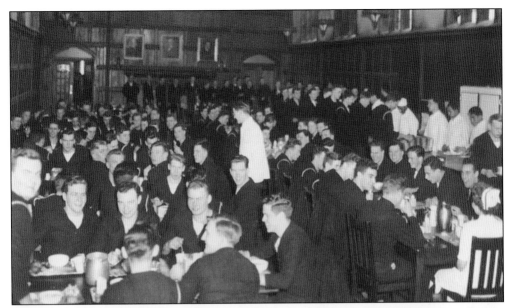

The sailors were served meals before the rest of the students in the S.W. Bowne refectory. Although they were officially at "mess," there was nothing disorderly about these boys. In fact, they were most certainly on their best behavior to impress the lone female in their midst. Hopefully, the kitchen provided enough crusty bread to work out those serviceable teeth.

Here, the saviors of Drew University, women and sailors who had kept the school solvent in a time of crisis, congregate on Mead Hall's steps. By war's end in 1945, the whites had all departed, while the female students grew in numbers large enough to merit their own dean, Mrs. Florence H. Morris.

The University in the Forest was again changing. In 1945, women outnumbered men. Two years later, veterans taking advantage of the GI Bill made up half of the college enrollment. With the school flush once again, the male students and alumni pushed for a return to the pre-coed days. But faculty support and the women's own resolve gave trustees enough impetus to declare unanimously that Drew would be a coed institution forevermore.

## *Five*

# THE EDIFICE COMPLEX

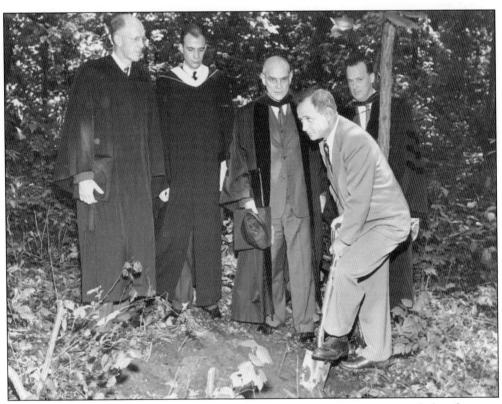

With enrollment and financial worries temporarily in the past, Drew now needed to focus on aging and inadequate campus facilities. Arlo Ayres Brown, who so capably saw the school through the lean years, left that challenge to his successor. Seminary dean Fred Garrigus Holloway, Class of 1921—who had led Westminster Theological Seminary and Western Maryland College—was up to the task. Groundbreakings became a familiar scene during his tenure. In this photograph, Martin Warshaw, president of the College Alumni Association, digs the first dirt for the Baldwin Gymnasium.

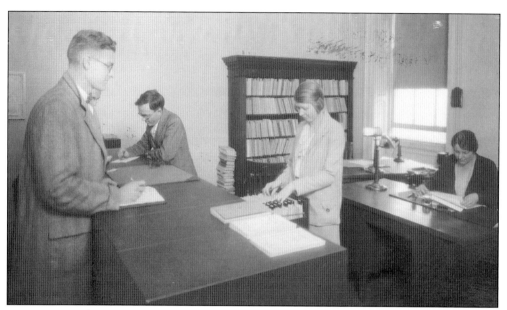

Registrar F. Taylor Jones, shown behind the counter in his second-floor office in Mead Hall, deserved much credit for the boost in enrollment following the war. Jones kept Drew servicemen across the globe apprised of campus happenings in the Drew *Gateway* and Brothers College *Alumnus*. More importantly, he advised them how they could continue their education at war's end on Uncle Sam's GI Bill largess.

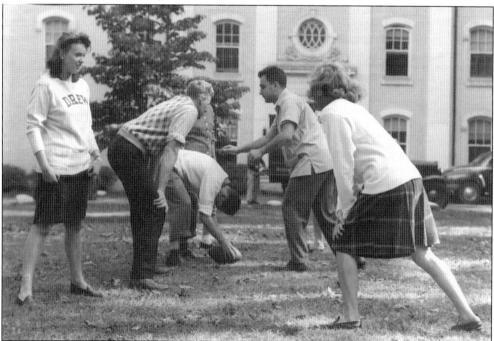

Although some college men protested women's permanent status on campus, they quickly came around. A game of pickup football in front of Asbury Hall became a place to show off athletic prowess and maybe find a date for Saturday night. These games are reminiscent of the Kennedy clan's family games at Hyannis.

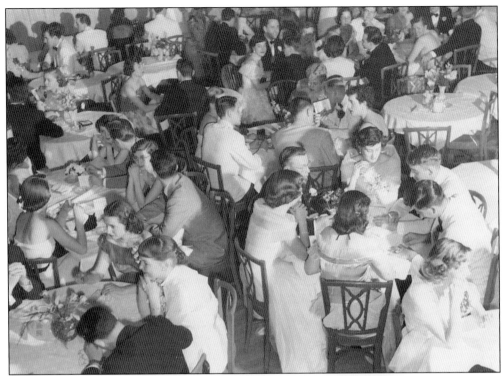

With people eager to put the dark days behind them, the 1950s emerged as a time of optimism. College seniors wanted to grasp the opportunities awaiting them. On the verge of adulthood and determined to look the part, they dressed to the nines for the 1951 spring prom that was held at the Hotel Suburban in nearby Summit.

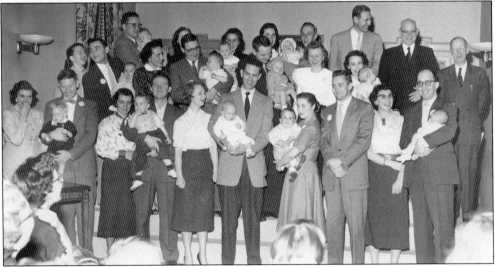

Both in the larger society and on the campus, the baby boom had begun. The baby boomers who would play a critical role in the university's future made their debuts with much doting from proud parents, such as these in the Theological School. In this baby contest, the judges who were roped into the indelicate task of choosing one child over another were none other than President Holloway, Prof. Stanley Hopper, and Prof. John Paterson (rear right).

During the 1950s, *The Acorn*—used in the past by students who wanted to sound off about everything from Adolph Hitler to the sanctity of all-male institutions—reverted to innocuous coverage of campus events and sports contests, especially the newly established varsity soccer. Editorials lodged complaints about food and facilities, but little else beyond the university's stone gateway. Not even the Korean War fully stirred the passions of Drew's budding journalists.

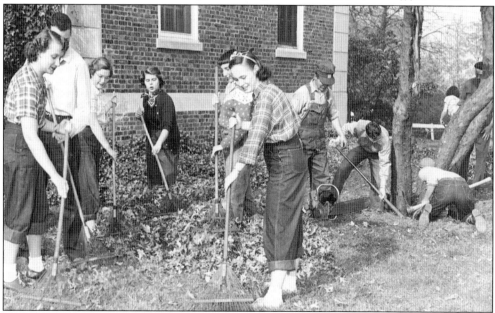

If not activists, the students were hard workers. Like the generations before them, they not only took their studies seriously, but they also often held off-campus jobs to pay for tuition. In their own quiet way, they aimed to make the world, or at least the university, a better place. These campus club members, sporting the uniform of the day—blue jeans—found their calling at the end of a rake.

74

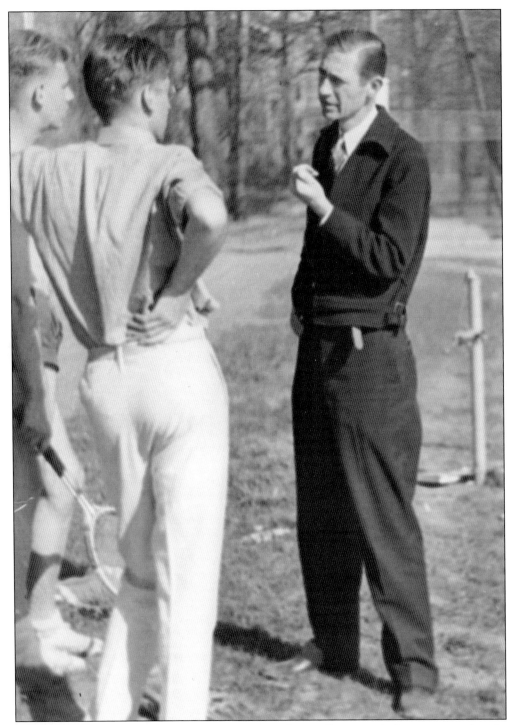

In the key academic achievement of his tenure, President Holloway made Drew a true university with the addition of a graduate school in 1955. To lead that school, he tapped one of the seminary's established scholars, Stanley R. Hopper. Hopper, who was well respected for his academic merits, was also the beloved Brothers College tennis coach for many years.

Despite academic improvements, President Holloway's focus was clearly the physical plant. Six new dormitories rose in the Forest under his watch to accommodate the burgeoning college enrollment and the influx of married seminarians. The $500,000 Wendel Hall went up first, with room for 45 seminary couples, many of whom had children in tow.

When Baldwin Hall was built two years later for the college men, women moved their belongings into Asbury Hall. Asbury became a safe haven for the bobby sox and poodle skirt set; it was a place where they could lounge in curlers and cold cream without concern over their appearance. For that very reason, a decade later, many female students reacted unenthusiastically to the push for unrestricted dormitory visits by men.

In addition to residence halls, President Holloway recognized the need for a new gymnasium and natatorium. The Bowne Gymnasium, opened in 1910, had seemed state-of-the-art to the seminarians who had been exercising in a little white shack alongside Embury. However, it was now hopelessly outmoded. Its pool, despite the liberal addition of chlorine, left those who plunged in feeling in need of a shower afterward with an extra lathering of Ivory soap.

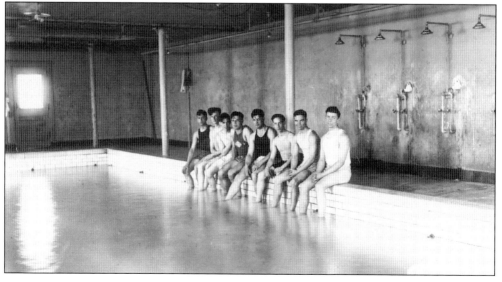

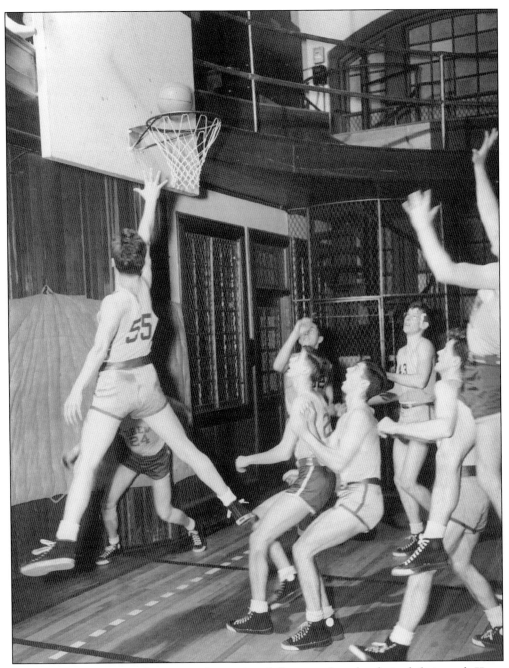

The basketball court in the Bowne Gymnasium left so much to be desired that coach Harry Simester had begun booking his basketball contests off campus. The running track and seating area located in a low-hanging balcony of the gymnasium not only distracted opposing teams, but the Circuit Riders as well. Who knows how many court advantages were lost when a fan's protruding penny loafer deflected the ball?

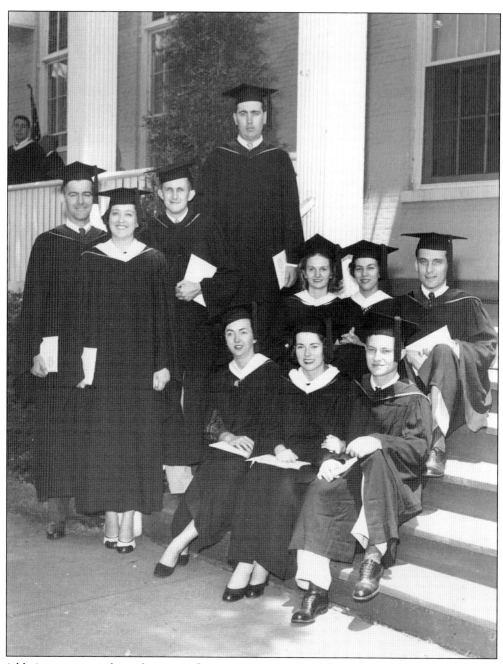

Athletics were not the only reason for a new gymnasium. These five married couples, who earned ten degrees in total from the college and seminary in 1953, were indicative of the larger graduating classes in need of a place to assemble for commencement.

The back porch of Mead Hall was then and still is the preferred place for presenting diplomas, with admiring families watching from folding chairs on the lawn. But rainy days sent the graduates running for cover to Craig Chapel. Those Seminary Hall ceremonies, like this one in 1945 when the V-12ers were still on campus, invariably left most spectators lining the hot corridors and stairwells, fanning themselves while hoping for a glimpse of a mortar board.

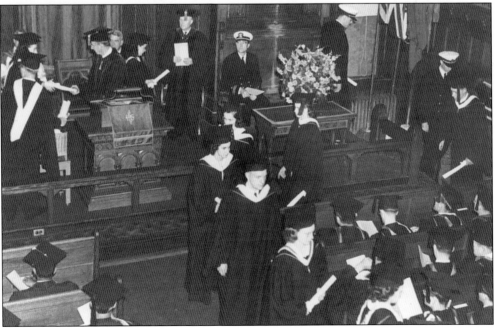

The $900,000 Donald R. Baldwin Gymnasium, named for the president of the Drew trustees and the son of Brothers College founder Arthur Baldwin, opened in 1958 to the delight of the entire Drew community. Now if graduates and friends faced a downpour, at least they knew ample shelter awaited. However, the auditorium still lacked air conditioning, so printed commencement programs doubled as keepsakes and fans.

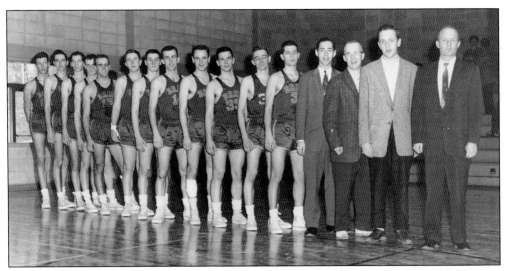

The new facility gave Harry Simester's boys a proud place to call home. Unfortunately, the green and gold did not go on to win many games that opening season, pulling down a glum two wins out of a possible 15. In the 1958–1959 school year, they showed little improvement, ending the year with a 3–14 record. Sadly, a winning season eluded the team until 1974.

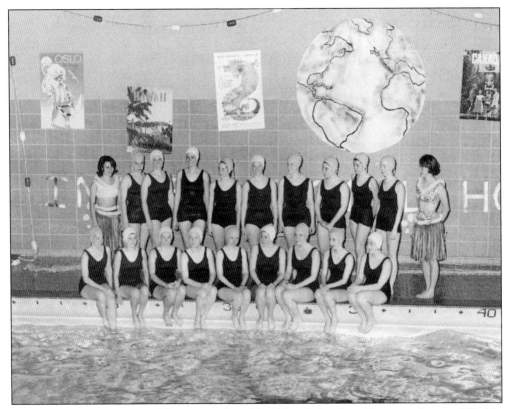

The new natatorium, named for trustee Donald Baldwin's brother, Morgan, who was killed in action in France during World War I, really suited the synchers. The pool's clear waters were a far cry from Bowne Gymnasium's murky depths and a perfect showcase for a water ballet.

Before the 1950s ended, Holloway began the construction of two more dormitories and broke ground for a university center. Called "Drew's busiest trowel wielder," he was also its most financially fearless: all three buildings were funded in large part by government loans. The new university center provided a great change in dining experience for the 400 or so hungry students who had grown accustomed to eating in the dark refectory under a portrait of Samuel Bowne. His somber countenance had almost seemed to admonish, "Sit up straight and clean your plate."

Besides a modern dining facility, the university center housed game and activity rooms, a bookstore, and a post office. Here, the Madison postmaster shows off the new mailboxes to treasurer John Pepin (center). Pepin, hired by Holloway, would shortly replace him as an interim president. In fact, in years to come, the unflappable diplomat would go on to serve two more presidents and hold another interim presidency.

Before Holloway could start a fundraising campaign for a much needed science building, the Methodist Church made him an offer he could not, in good conscience, refuse. Chosen to serve as bishop, he would be gone before the 1960s got underway. Here, the tireless builder poses with the Class of 1959's Jean Padberg Miller and Donald Cole. Cole would actually see Drew into the new millennium, becoming a well-respected professor of economics (sans saddle shoes, of course).

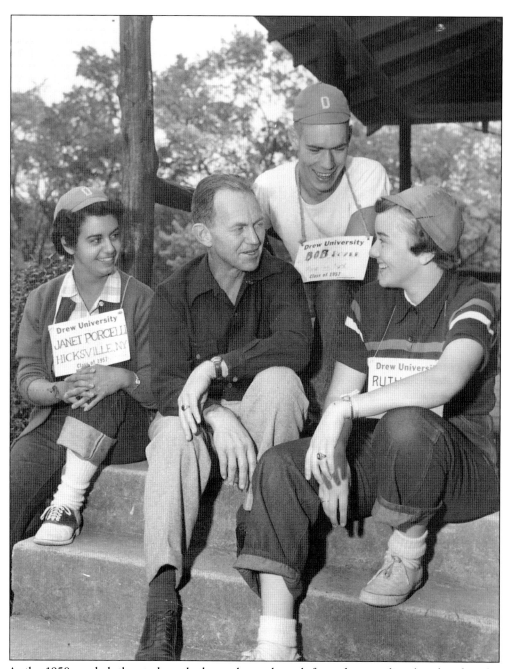

As the 1950s ended, the students had not changed much from those earlier that decade, who started their college careers sporting "dinks" and "can't miss" placards around their necks. But soon, fresh-faced freshmen—such as these students gathered around Professor James A. McClintock—would go the way of the Edsel, caught up in the waves of contention that swept the nation.

*Six*

# TRANSITION AND TURMOIL

The complacency of the 1950s did not suit eighth president Robert Fisher Oxnam, the first Drew leader who was not a Methodist minister. In his inauguration speech on October 12, 1961, the former president of Pratt Institute in Brooklyn decried the "provincialism and contentment" on campus and urged the community to concern itself with the greater "social, economic, and political problems" of the day. In hindsight, he may have wished he heeded the adage, "Be careful of what you wish for."

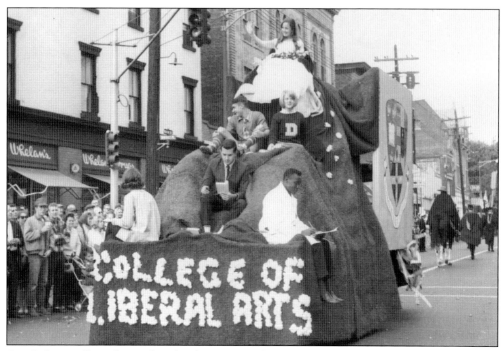

Good clean college fun endured, of course; in fact, it still exists on campus today, although the entertainment has changed some with the times. Back in 1964, Drew collegians still looked buttoned down and clean cut atop their float in Madison's Tercentenary Parade. You could even catch a glimpse of a Drew seminarian on horseback, representing the early Methodist circuit riders. Chrysanthemum queens, such as the one pictured below with the wife of the president, Mrs. Dalys Oxnam, also continued to reign throughout the decade.

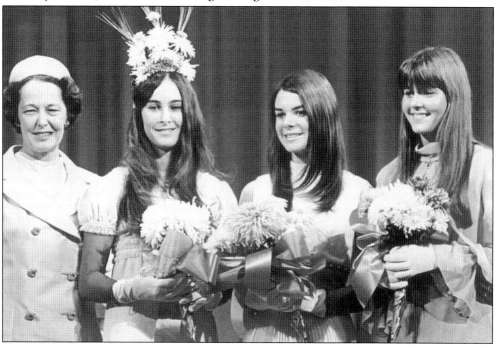

These students were a different breed from those of other generations. The differences became more apparent with each passing year, as these two freshman orientation photographs indicate. In the 1965 photograph above, dinks still sat atop the underclassmen's heads and the identifying placards were still dutifully worn around their necks. Four years later, the freshmen crowd below looked every bit the Woodstock generation. There was not a dink to be found, but the one placard remaining spoke volumes—these young people had put the past behind them.

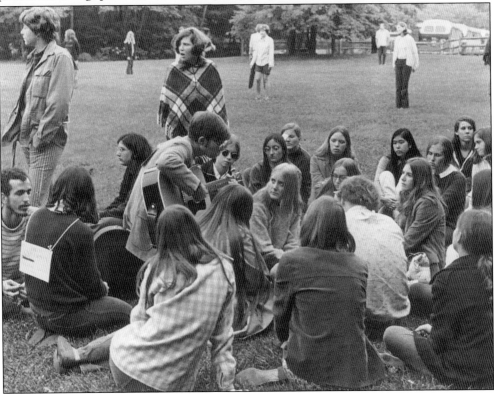

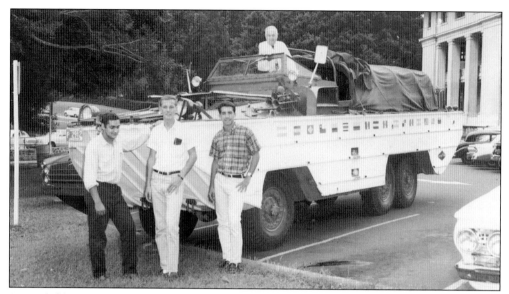

A march blasting poor communication on campus, just months after his arrival, let President Oxnam know that this student body would be complacent no more. Students also began looking to make their mark outside Drew's walls. In 1962, seven hardy souls embarked on a 27,000-mile goodwill tour of South America in this surplus U.S. Army amphibious vehicle. When the "Brave Duck" rammed a reef, the seven stranded castaways spent two weeks on a veritable Gilligan's Island in Colombia.

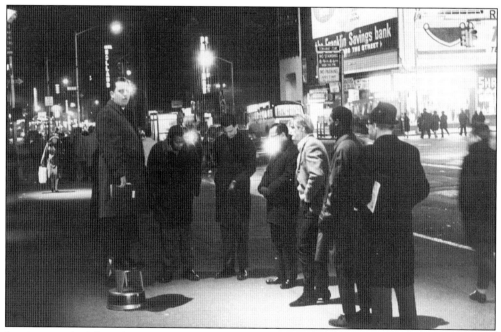

Seminarians had long been committed to outreach in the wider world, both as missionaries around the globe and in America's impoverished cities. In the 1960s, that city mission work, begun nearly a century before, took form as the Church Without Walls. Atop a stepstool, preachers like this one shared their message with the masses under the garish marquee lights lining a Manhattan thoroughfare.

Professors did much to remove any lingering ivory-towered notions by offering course work out in the real world. With field journals in hand, botany professor Robert Zuck is pictured here escorting his class to the rocky shores of New England for a lesson. The semester on the United Nations, started in 1962 in New York, paved the way for extended study off campus. Students soon ventured into Manhattan to study art in galleries; they also journeyed to the nation's capital for a close look at politics. Undergraduates also embraced study abroad when semesters in London (1963) and Brussels (1966) debuted, while adventurous seminarians traveled to Scotland for a full year of instruction.

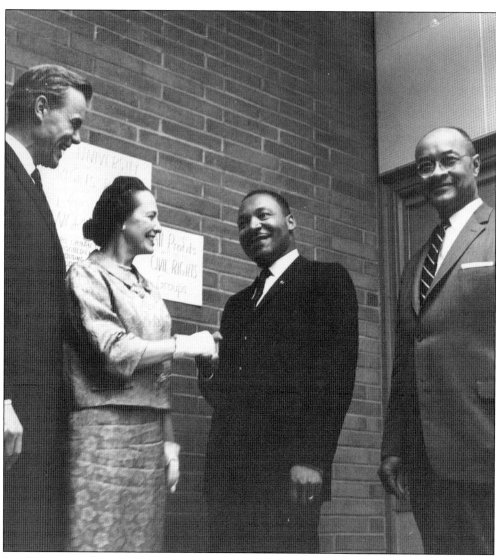

Speakers and performers fueled this new interest in national and international affairs by bringing their messages to the Forest and, sometimes, the controversies that followed them. In 1964, when Martin Luther King Jr. challenged a record-breaking crowd in Baldwin Gymnasium to champion civil rights, someone leafleted the cars parked outside with charges of King's alleged communist connections.

During visits to campus, consumer advocate Ralph Nader (top left) counseled students on their civic duty, while pop singer Judy Collins (top right) moved them to action with her stirring soprano. Folk singer Pete Seeger (below) returned to Drew again and again, recruiting more young people each time to any number of causes, from peace and justice for all to environmental protection. With students' passions enflamed, it was only a matter of time before the University in the Forest would erupt like others around the country.

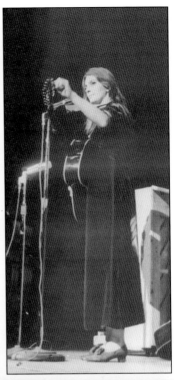

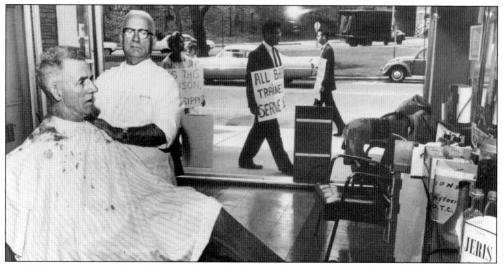

In 1964, two months after Martin Luther King's plea for equality, students and faculty from all three schools began an organized picketing of Dalena's Barber Shop in Madison. Dalena had refused to cut the hair of a pastor visiting the seminary from India, because, he said he lacked the proper tools and training "to cut a Negro's hair."

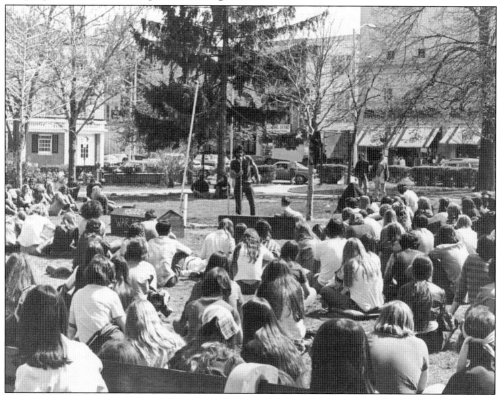

After the barbershop incident, opposition to the war in Vietnam began rising. Antiwar fervor propelled students to demonstrate on campus, in neighboring towns, and in Washington, D.C. In this rally on the Morristown green, protesters are calling for a moratorium after President Nixon's announcement that troops had moved into Cambodia.

Nothing rocked the campus as deeply as
the upheaval in the Theological School.
As the seminary's centennial approached,
disagreements between President Oxnam and
Dean Charles Ranson over budgetary matters
grew increasingly heated. The simmering
passions boiled over after the president balked
at the salaries requested to fill faculty vacancies,
including the post once held by Prof. Carl
Michalson (right). The internationally acclaimed
professor's death in a 1965 plane crash had
devastated the seminary. Bypassing Oxnam,
the faculty and dean sent a plea to the trustees,
an impropriety that led to Ranson's dismissal,
angry protests by students, and the subsequent
resignations of a dozen professors.

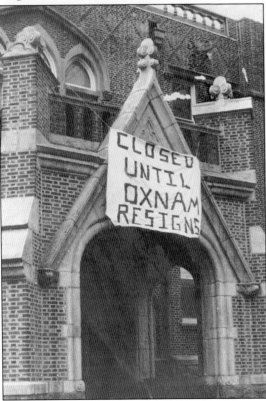

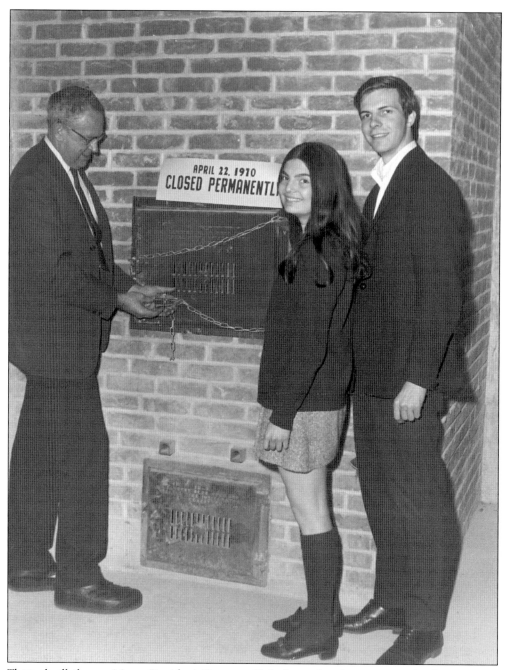

Through all the uprisings, President Oxnam still had a university to run and other pressing matters to consider. Protecting the environment had become a national crusade, and Oxnam showed his commitment to the cause on Earth Day, April 22, 1970, by authorizing the shutdown of five campus incinerators. Plant director Ralph Smith is shown padlocking the Brown Hall furnace alongside Drew Environment Committee chair Richard Shepard and member Louise Kittel.

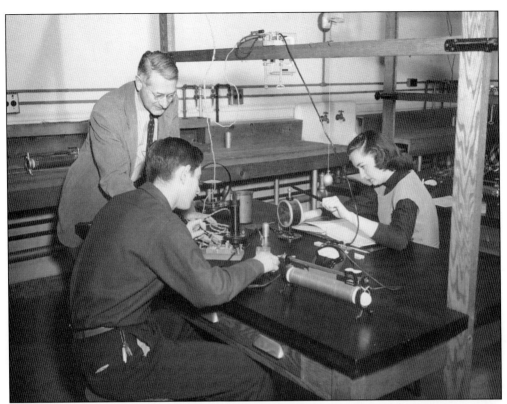

Like his predecessor, President Oxnam had some building to do. Back in the 1940s and 1950s, students like the ones shown in Prof. Marshall Harrington's physics class were adequately served by the science facilities in Brothers College basement. However, by the 1960s, the labs and equipment just would not do. Oxnam and his advisers targeted Rogers House for demolition and challenged the architect to build a structure that would complement, but in no way detract from the adjoining Brothers College.

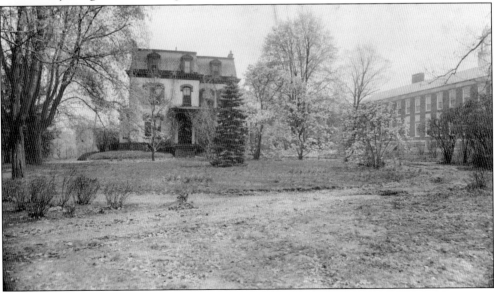

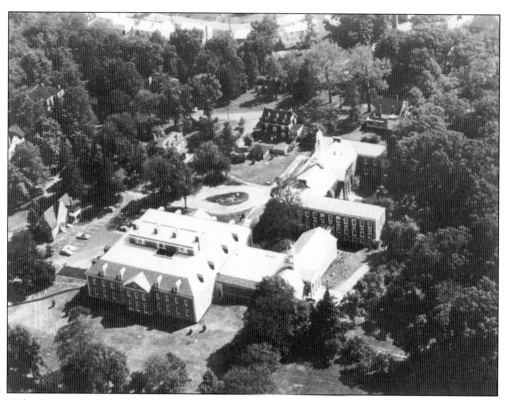

Architect Frank Bower certainly surpassed everyone's expectations. The Hall of Sciences, although twice the size of Brothers College as seen in this aerial view, was classic in its design and layout. So happy was he with his work, Bower declared the building to be "the best thing I've ever done." Students were either satisfied with the facility, which was dedicated in 1968, or too occupied by world affairs and other campus matters to register a complaint.

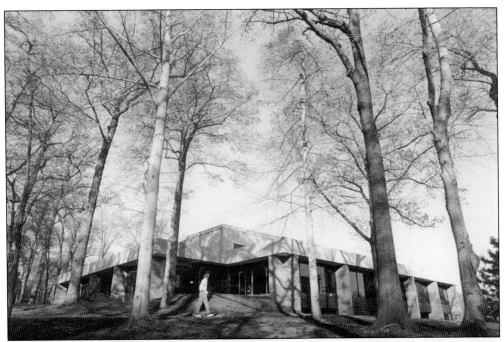

Oxnam did not fare as well with the University Commons, which opened in 1972. Despite windows that offered a panoramic view of the oaks, room enough for a faculty dining area, and eventually a black box student theater, students criticized the building's design, comparing it to an airline terminal. More angrily, they objected to the increase in fees and the new meal plan instituted to help pay for and operate the facility.

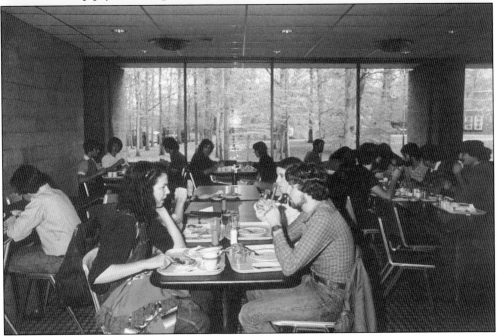

Oxnam may have been disheartened, but he was likely not surprised when 200 students took to campus paths in protest of the meal hike, threatening to boycott preregistration. Certainly, he had lived through worse, and tragically the worst was still to come. The following winter, four staff employees were assaulted and their assailants never found. Then, in April 1974, Oxnam was diagnosed with lung cancer, a disease that would take his life in three short months. With each passing decade, empathy deepens for the trials he endured during his tenure, while appreciation grows for his many accomplishments.

# *Seven*

# EXCITEMENT AND
# AUDACITY

Paul G. Hardin, Drew University's ninth president, sought student rapport after his inauguration on September 26, 1975. A soft-spoken son of a noted Methodist bishop, Hardin combined his impressive academic credentials with a knack for spreading the story of Drew's top rank among universities that stressed academic excellence. Seeking dramatic ways to counteract nationwide declines in campus enrollments, he urged the veteran Drew faculty to submit ideas. Excitement and audacity enveloped the campus. A reporter attributed Hardin's success to "a gracious and gentle Southern accent that belies a cool self-assurance—that some might see as arrogance—although he seems to remain unostentatious."

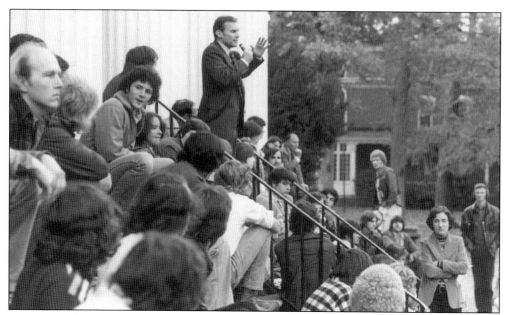

As his administration progressed, Hardin met with students, often to dispel complaints that he did not listen to student voices that ranged from traditional gripes about food to a student concern for people and policies in nations throughout the world. In this photograph, he assures angry students at a sit-in on the steps of Mead Hall in October 1977 that he will work to protect student rights.

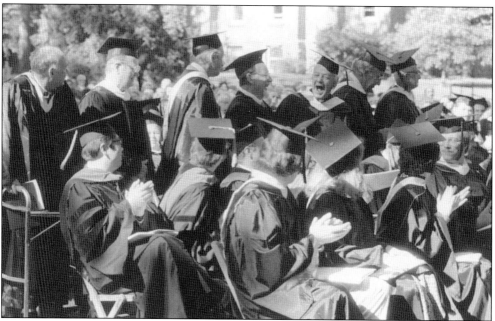

On September 30, 1978, the university celebrated the golden anniversary of the first class that entered the College of Liberal Arts in 1928. Seven members of the remaining nine graduates of the initial class returned for the September convocation. They are, from left to right, Faulkner Lewis, Herbert Dabinett, Johnston Stewart, Robert Powell, Leon Flanders, Robert Kellerman, and Misak Murdichian.

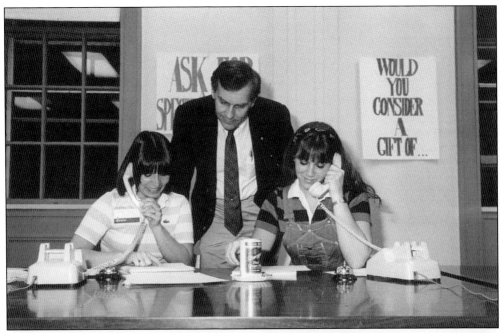

Hardin sought to solidify relationships with graduates of the College of Liberal Arts by visiting alumni operating telephones during an annual alumni fund drive. Posters on the wall reminded callers of the need to get a pledge and, if possible, boost the first proposal by asking, "Would you consider a gift of . . . ?"

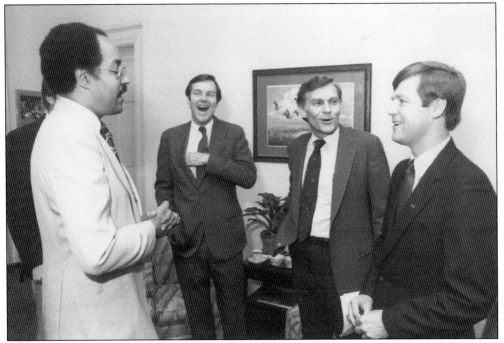

Visitors of state and national prominence often visited Hardin in his office. On the occasion shown here, members of the faculty enjoy a Hardin *bon mot*, as does New Jersey governor Thomas Kean, shown laughing most heartily.

In October 1980, Drew announced a $10.6 million campaign that would thoroughly refurbish Rose Memorial Library ($2.2 million), add a modern learning center to the library ($4.4 million), bring the prestigious Methodist Archives Center to a new building on campus ($2.75 million), and build quarters for the Research Institute for Scientists Emeriti ($1.25 million). The Methodist Archives building is shown at left. The entrance to the learning center is below.

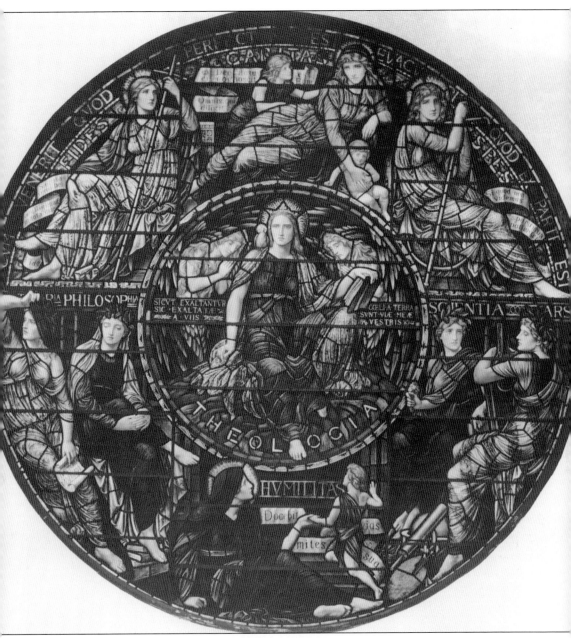

When the Cornell Library was razed in 1938 to make way for the Rose Memorial Library, no one missed the 9.5-foot diameter stained-glass window that had brightened the old library for decades. When someone finally remembered it, the window had vanished. The precious window (called the Rose Window because of its design) had been dismantled by an unidentified person and packed in wooden cases. It was moved about the campus incognito until the boxed pieces were discovered during third floor alterations of the science building. The architect redrew his plans and carefully placed the recovered window over the main entrance to the new learning center.

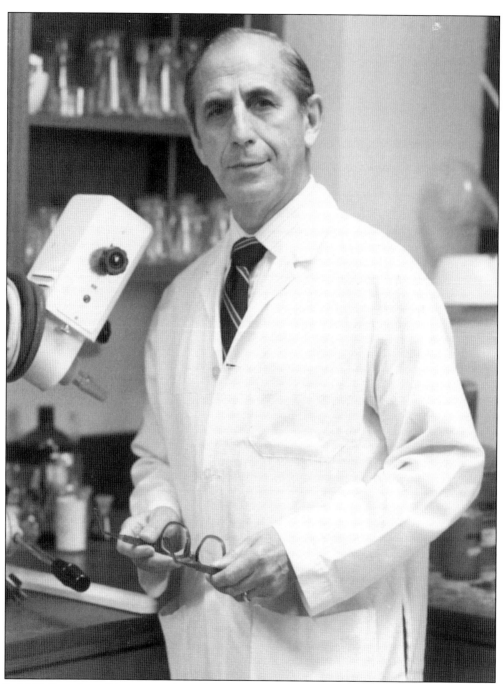

In 1978, Drew's traditions in teaching the sciences led to a pairing of George deStevens (shown here) and a unique university program, the Research Institute for Scientists Emeriti (RISE). DeStevens, head of research for the major pharmaceutical firm of Ciba-Geigy, met Hardin in a golf match at a nearby country club. In 1979, after he was felled by a bleeding ulcer, deStevens took early retirement to head RISE. The program enlists retired scientists to carry on their research and to teach undergraduates; it became a rare mating of top minds and aspiring scientists.

The ability to garner top undergraduates from many facets of society gave Drew an enviable reputation. Substantial scholarships and grant money during the 1980s and beyond helped many bright young people who could not have attended the university (or perhaps any university) without encouragement and substantial financial support.

Personal computers were in a relative infancy in 1984, when Drew became the first liberal arts institution to provide computers for all students. By 1990, personal computers were the major link in a program that connected students with the library and enabled them to exchange messages with one another, their professors, and parents who owned home computers. Freshmen entering in 1984 found computers in their rooms. Within three years, every student had his or her own computer.

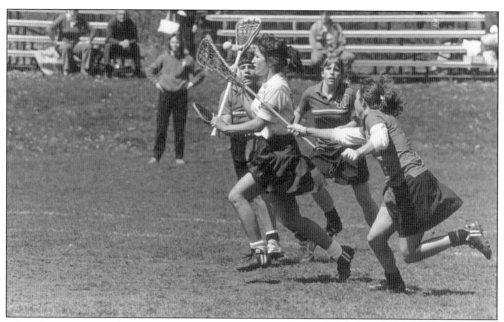

When Congress passed its landmark federal financing of education law in 1972, one provision, or title, stipulated that all college activities (including sports) must be sex-equal. Drew had no trouble adjusting to Title IX. Women had been participating in sports programs since they first arrived on campus. By 1980, women competed in a variety of vigorous sports, including lacrosse. Today, eight men's teams, nine women's teams, and one coed squad compete in intercollegiate athletics.

Winter sports open each year with the popular Rose City Classic, at one time the largest intercollegiate basketball tournament in New Jersey. Students from competing schools pack the gymnasium to see good basketball by teams from within and beyond New Jersey. A home team victory results in the pandemonium of bursting balloons, tossed confetti, and thunderous noise.

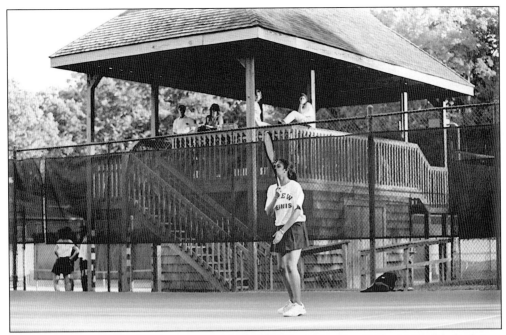

Drew's athletic facilities became superior in the Hardin years. One that met his standards was the $600,000 state-of-the-art tennis complex opened in 1987. The courts surrounded a Victorian-style viewing gazebo. Watchers could see every court from some point in the gazebo.

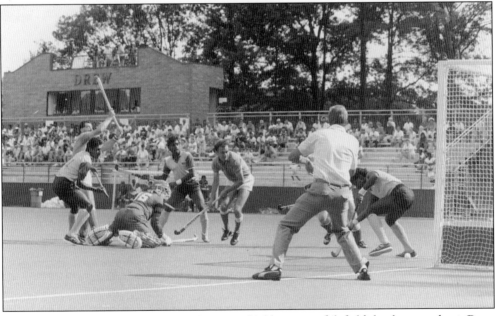

During Hardin's regime, Maureen Horan, a highly successful field hockey coach at Drew convinced the U.S. Field Hockey Association and the men's Field Hockey Association of America to join Drew in building a $2 million field in 1988. It would serve when needed as a training ground for U.S. men's Olympic field hockey teams. At all other times, it would be the home field for the university's men's and women's soccer and lacrosse teams and the women's field hockey squads. Twelve nations sent teams to the opening of the stadium in July 1989.

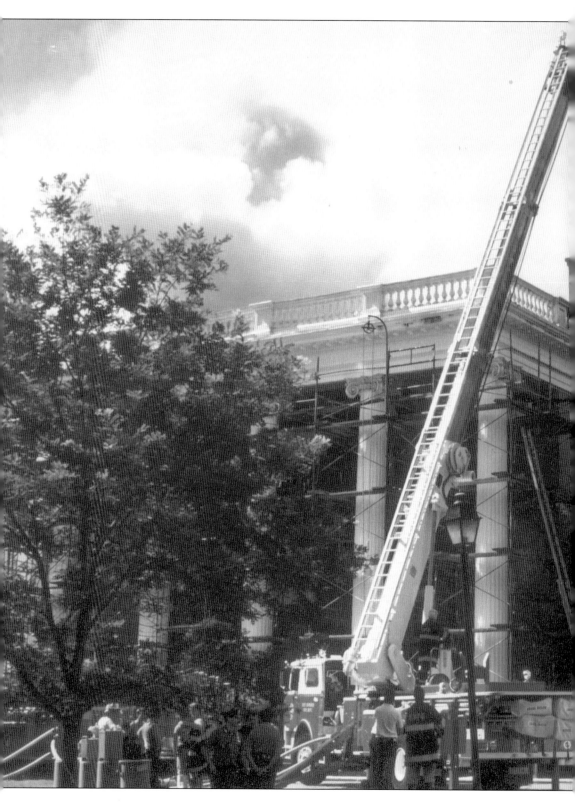

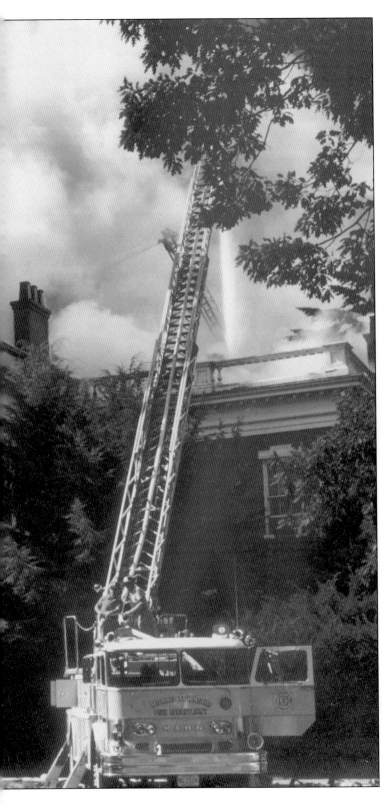

Hardin left Drew in May 1988 to become chancellor of the University of North Carolina. On August 24, 1989, interim president W. Scott McDonald drove onto the campus to see a wisp of smoke curling from the roof of Mead Hall. An on-the-scene fire department said the small fire was under control. Instead, it burned for 23 hours, ruining the interior. Mead Hall, 153 years old, had been the heart of the university from its inception. Fire departments from seven surrounding municipal departments poured 2.3 million gallons of water into the building before the fire was officially squelched. Miraculously, little of the building's valuable furnishings had been destroyed, despite the extensive damage wrought to the esteemed Greek Revival mansion.

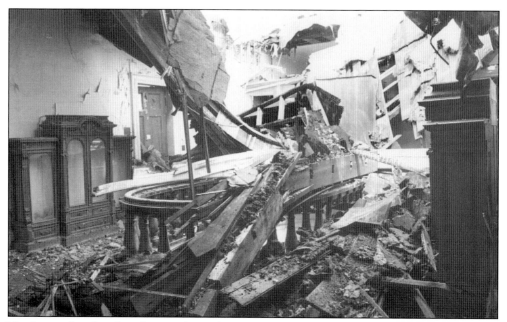

Massive roof and ceiling beams that collapsed during the fire plunged downward to strike savagely at the mahogany second floor balustrade. As proof of the building's durability and strength, the balustrade stood firmly, little damaged and only slightly scarred. From such scenes of disaster, repeated in every room on every floor, the reconstruction would begin.

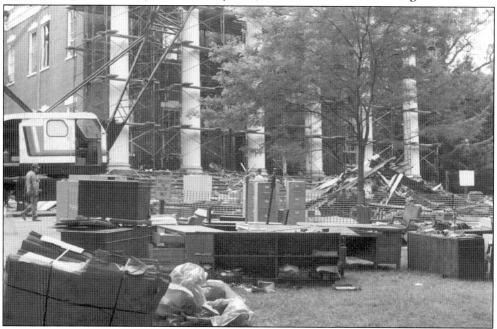

Within minutes after the blaze intensified, the administrative staff, faculty, students, and alumni, attracted by the news of the inferno, entered the building and heroically brought out precious antiques, priceless paintings, and valuable records. They were piled on the lawn to await storing. Lending strength were the six Ionic columns of Mead Hall, rising from the only slightly damaged front piazza.

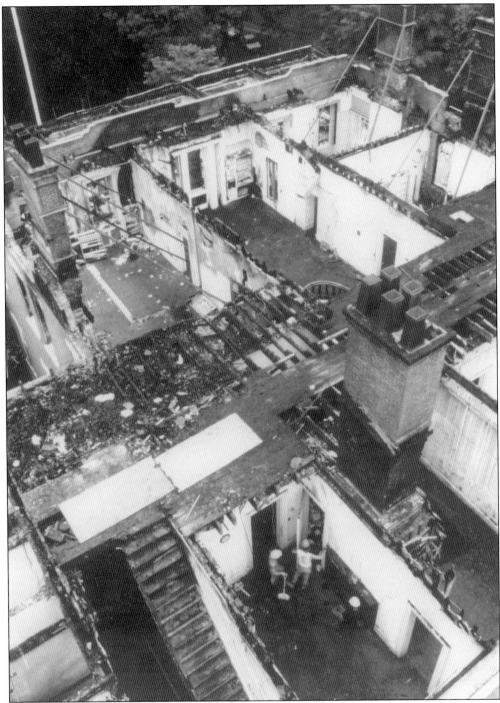

Firemen finally stopped the fire by bringing in a huge crane to rip off the copper and tin roof. Viewed from the crane two weeks later, Mead Hall's brick walls still stood and the second floor's room walls were in place, but the building looked like a giant's ravaged doll house. Faced with the ruins, McDonald and the university administration agreed the historic, beloved building had to be restored.

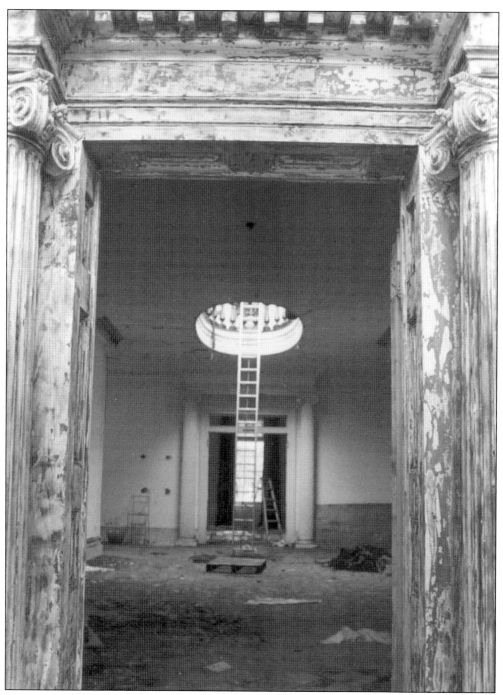

Looking through the fire-pocked front entrance, the glow beneath the skylight in the main hall signified powerful hope. The building had to be cleared of the fallen debris, and a long ladder to the second floor balustrade had to serve until a new stairway could be built. However, within the ruin, hope was paramount; strong insurance policies covered most of the damage and alumna Alice Glock's painstaking inventory of the structure and its contents, dating to 1979, solidified university claims.

# *Eight*

# TOWARD TOMORROW

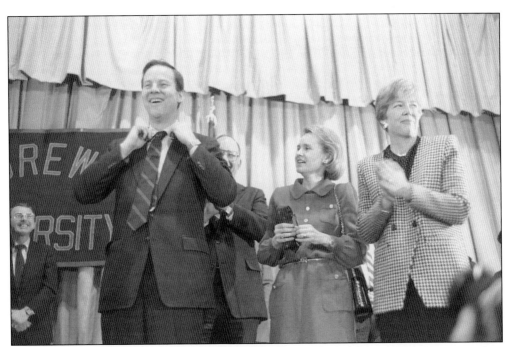

On February 10, 1989, Drew finally received what it had sought for years—the media's attention. From local papers to major networks, reports of New Jersey governor Thomas H. Kean's acceptance as the school's tenth president cast all eyes on Madison's little University in the Forest. Although he may not have realized it, from the moment he tied Drew's Oxford blue and Lincoln green tie around his neck, President Kean began fulfilling his pledge to "enable people all over this country, and perhaps the world, to understand how good a thing we have in Drew University."

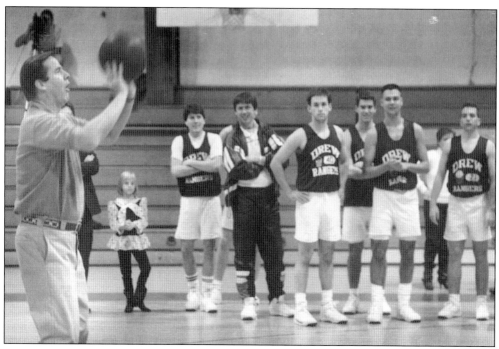

A media blitz greeted President Kean for much of his first year. Camera crews were particularly interested in capturing the president with students. For Kean, those interactions were not just photograph opportunities. Long after journalists turned their sights elsewhere, the former governor was still lunching with students in the commons and applauding front row center at theater performances and Ranger games. Students were his focus whether he was stepping up to the free-throw line during the basketball team's Shootout for Epilepsy or teaching his course on government to those lucky enough to register early.

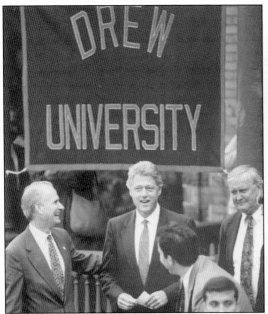

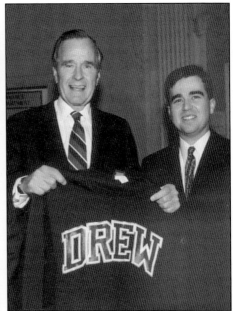

Drew made headlines, too, with a steady stream of VIPs wending their way to campus. Not surprisingly, many were political heavyweights, friends of the former governor. During the 1992 presidential campaign, Drew hosted both Pres. George Bush and Gov. Bill Clinton of Arkansas. Eventually, First Ladies Barbara Bush and Hillary Rodham Clinton would address the community as well.

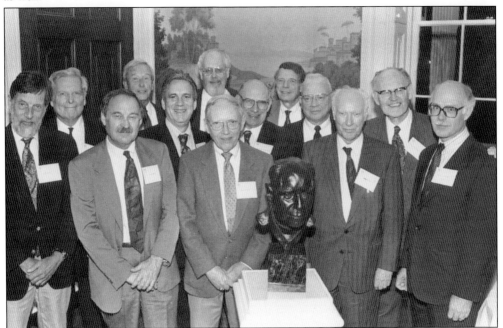

Along with inviting new friends to Drew, the university welcomed back some dear old ones. Many of the seminary's professors who had resigned in anger during the 1967 protest over Dean Ranson's dismissal came back during the Vosburgh lectures in 1993 for a reunion with each other, former students, and former colleagues. At long last, some old wounds were healing.

117

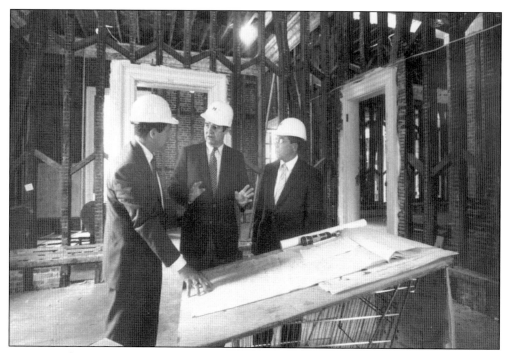

Appropriately, one of the new president's immediate concerns was to make Mead Hall operational again. Thanks to a "Cadillac policy" set up by interim president W. Scott McDonald, insurance would cover much of the $10 million restoration, while the rest would come from grants and gifts. Kean and others marched potential donors, like those pictured, through the building's shell, painting a picture of what could be done if only they would help to make it happen. Meanwhile, conservators and craftsmen painstakingly restored the art and furnishings damaged in the blaze.

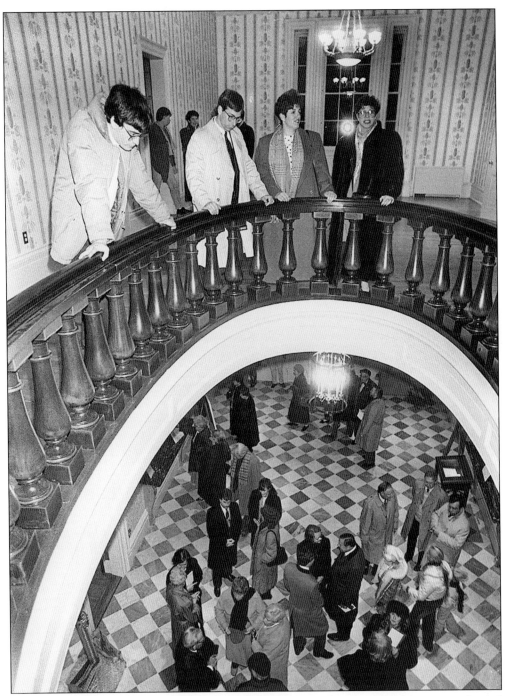

When Mead Hall's freshly painted doors opened again December 8, 1992, visitors were dazzled by the mansion's 19th-century charm. Period paint colors and wallpaper graced the walls. Several fireplaces that had been covered over were now exposed. Chandeliers and ornate plaster accents were restored. But that historic integrity was blended with 21st-century priorities, like air conditioning, an elevator to ensure accessibility for all, and, of course, modern fire safety systems.

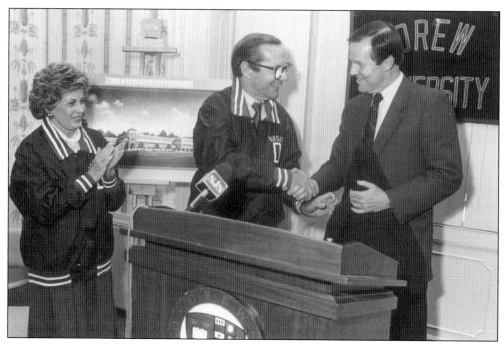

As Mead Hall gained its finishing touches, the next great building project of the decade was already taking shape alongside Baldwin Gym. In a few months, the long-anticipated and sorely needed athletic center and forum would gain its name and $2.5 million in support from William and Carol Simon, shown here sporting school colors. Theirs was then the largest gift in the school's history from a living donor.

The Simon Forum opened in January 1994; it was the snowiest winter in recent memory. Because of the chill, faculty, staff, and students in residence for the January term had grown accustomed to eating lunch at desks or in dorm rooms and following up with a good book. The magnificent center, with its many possibilities for play and exercise, changed all that.

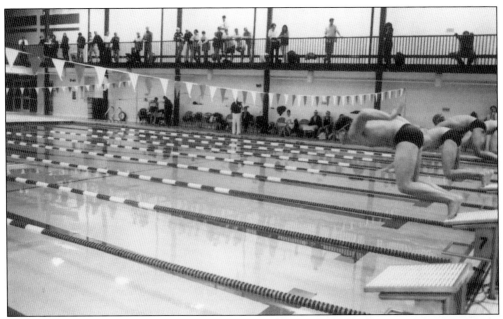

A fitness craze swept the campus. How could it not? Passing by the eight-lane pool's blue waters, looking down on the racquetball and squash courts, and coming upon a room of stair machines, treadmills, and weight-training equipment, even the most sedentary visitors felt their hearts beat a little quicker at the possibilities.

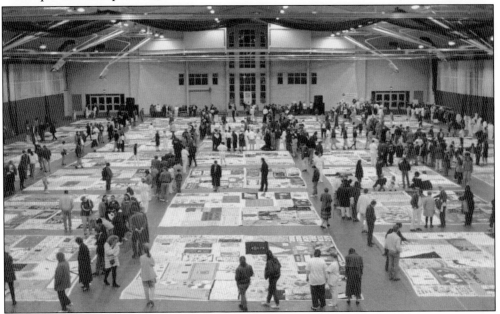

The real head turner was the forum itself. Inside its cavernous interior, four basketball games could be played simultaneously, while runners sprinted around the perimeter. Tennis players no longer needed to cancel practice due to rain or snow, and nearly 4,000 people could take in a speech or a concert without crowding. Double that number visited the forum in 1995, when 1,368 panels of the AIDS Memorial Quilt—the largest display ever in the state—were laid end to end across the floor.

Although President Kean, like his predecessors, was occupied almost continually with the repair or renovation of campus facilities, he championed scholarship and wanted to reward those most deserving. In 1991, he began presenting the President's Award for Distinguished Teaching at every spring commencement to a professor nominated by students and colleagues. Winners of the award, like psychology professor Jim Mills being applauded above, receive $10,000, half for themselves and half for an academic venture of their choosing.

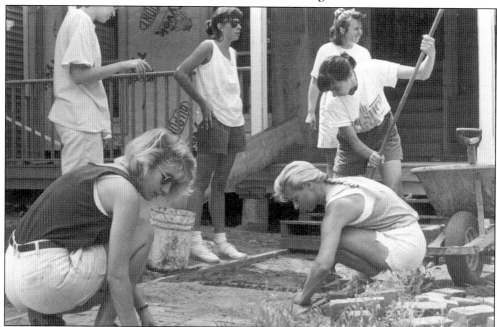

During the 1990s, long after the fitness craze cooled, renewed interest in volunteerism took hold. Whether sending books to Ethiopia, collecting canned goods and sweaters for local homeless, or building houses as part of Habitat for Humanity (as these workers did), students and alumni groups began looking beyond Drew's stone gateway to make a difference once again.

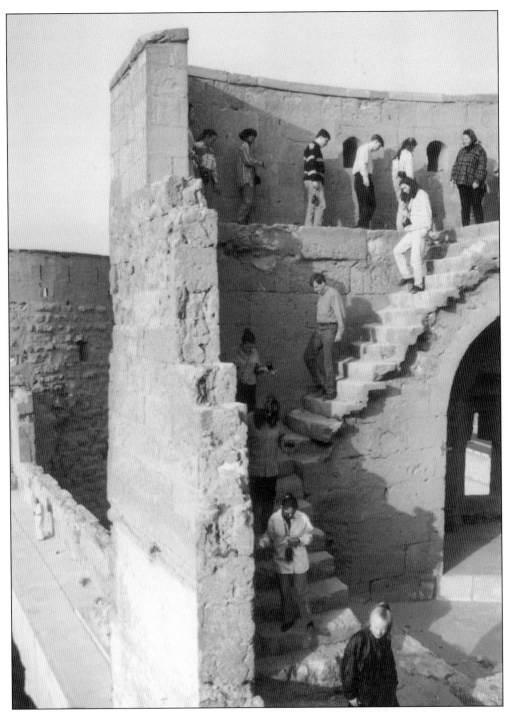

Study abroad, long a feature of the Drew experience, stepped up a notch with the introduction of International Seminars in 1994. Intended for sophomores, the seminars took students to faraway places—like Egypt and the walls of the Cairo citadel—for nearly a month, all for the cost of a standard summer course. Some students have found that the trips, which were always eye opening, could also be life changing.

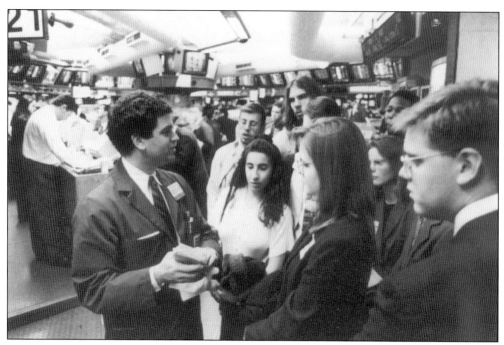

While students in past years would hop the bus or train into Manhattan for a lesson on art or United Nations diplomacy, aspiring traders and big money managers in 1997 began enrolling in the newly formed Wall Street Semester. On site, undergraduates often get firsthand accounts of mergers and acquisitions from alumni and trustees who make their living in the financial district.

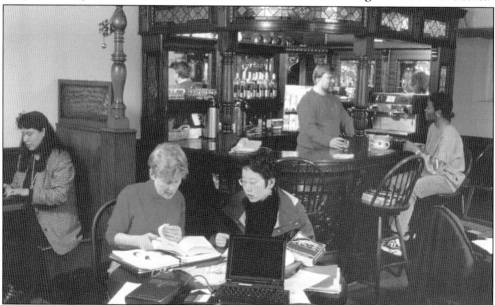

While the college continued its pursuit of hands-on learning this decade, the seminary embraced the electronic age. No longer was it enough to offer students computers to use and take after graduation. The Theological School, fueled by the new dean, Leonard Sweet, began reaching out with interactive courses online. An indicator of changing times, the Kirby lounge became the Kirby Cyber Café, a place where seminarians could surf the Internet while sipping a cappuccino.

The next major building transformation on campus was actually taken from concept to completion by the New Jersey Shakespeare Festival, in residence since 1972. Since the days of founders Paul and Ellen Barry, the festival had been performing feats of Shakespearean magic in Bowne Theatre, a structure worn out from its days as a gymnasium. Under the vision of new artistic director Bonnie Monte and with the support of Drew friends, the $7.5 million F.M. Kirby Shakespeare Theatre opened in 1998, letting patrons settle into plush seats, under state-of-the-art lights, to watch the Bard's canon come to life.

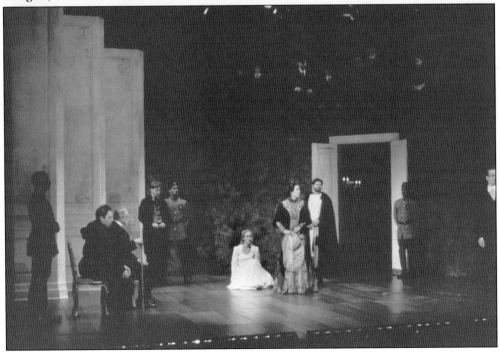

As the decade drew to a close, Drew received thrilling news: one of its college seniors had won a coveted Rhodes scholarship. This academic coup for Dena Pedynowski called to mind the good fortune of the college itself. Dena, you see, was also a Drew Scholar, her tuition covered by the generosity of the college's founding family—the Baldwins. That uncommon devotion to Drew on the part of the descendants of Arthur and Leonard reached another plateau before the year was out. Leonard's granddaughter, Eleanor Haselton Barrett, gave $5 million that fall to endow another scholarship, this time in her mother's name.

Just months before the Barrett gift, the university received a $5 million gift from trustee and Graduate School alumna Barbara Caspersen and her husband, Finn (shown with Kean and Dean James Pain). Pledged to the graduate school, their gift not only brought this smallest of the university's schools some long overdue recognition, but also prompted a name change to the Caspersen School of Graduate Studies.

Shortly after the announcement of the two $5 million gifts, the university confidently announced the start of the largest campaign in Drew's history during 1999's reunion weekend. Intending to fund scholarships, an arts center, and a new science wing, as well as the renovations of Seminary Hall and S.W. Bowne Hall, the Gateways to the Future campaign seeks to raise $62 million by December 2003.

With generations of alumni supporting Drew enthusiastically, the now well-known and respected University in the Forest simply cannot lose. Each June, graduates of the College of Liberal Arts march proudly in appreciation of their alma mater.